The Central Saint Martins Guide to Art & Design

T0385371

ilex

Exercises

Workshops

Interviews

Foreword

Grayson Perry

I often say to students I am not interested in people who want to be artists. I am only interested in people who want to make art. I draw this distinction because since I attended a foundation course in 1978 a career in art and design has become a much more attractive option. I think some people now come into that world because they like the idea of being a 'creative'. They fancy the identity of artist or designer. These people are externally referenced. In my experience the people who succeed in this business are those who are mainly internally referenced, in that they care more about how they feel on the inside than how it looks from the outside. They often live for their work. They enjoy the drudgery of repetitive tasks and polishing their skills as much as dreaming up new projects and celebrating them at parties. They love sewing a perfect sleeve, drawing a flowing line, getting the proportions in perfect harmony or a colour combination to sing. They would make art even if it was not their job. Do you think you could be one of these people? Then this is the book for you.

Do you want to make loads of money? Then maybe it is best that you look away now. Of course it is possible to have an extremely lucrative career in visual art. I am having one myself. But I am lucky, extremely lucky, and I did not make

a living wage from my art until I was 38 years old and I went to art college in the golden days before university fees! In some ways this is a good test. If you do not care whether you make lots of money then you may be well suited to joining my world. You care about heartbreaking beauty, fresh new ideas, astounding craftsmanship, ingenious solutions, the tingle of a shocking image. You want to join a world where other people feel the same as you and will support you in this. The art world is a stimulating and fulfilling place full of dedicated people but it is not an easy ride, it is not all fun. It is a marathon not a sprint. Success may come in the form of the respect of your peers or a deep sense of satisfaction while doing meaningful work or you might just love the end result. Good money may well come your way, eventually.

When I joined a foundation course I did not have a clue where I was headed, I just liked making stuff. I spent a year getting over the shock of making art full time while trying out lots of different disciplines. I gave myself up to the process, I did not have an end goal in sight apart from getting into art college, any art college, in order to get away from my parental home. I took the advice of the tutors, they said I was a fine artist. They were right, I did ok, but maybe I'd have been a better (and richer) fashion designer!

Introduction

This book is dedicated to the visual thinkers, makers and provocateurs.

A Foundation course is the first significant step in the process of becoming an artist or designer. From developing a personal visual language to critically analysing the potential of your ideas, you will build a foundation on which to thrive in the world of art and design. Follow practical projects and exercises, and feel encouraged to dream, imagine and design for a world that does not yet exist.

We want to engage you actively, creatively and critically. Use this book as a call to action: to explore, to question and to make.

As Foundation tutors at Central Saint Martins, University of the Arts London, we work in a highly selective and competitive environment, yet we believe that the core values and processes we teach are accessible to everybody. The aim of this book is to shed light on the strategies we use to explore and diagnose creative potential.

Whether you are pursuing a university degree in art and design or a career move into the creative industries, you will first need to situate yourself within the area where you can have the most impact. Discover where you fit through the five projects in chapter 7: Explore, which introduce you to the breadth of art and design. Then immerse yourself in an area of specialism through projects that focus on four key areas: fashion and textiles, fine art, communication design and three-dimensional design.

The discovery of an authentic voice and direction is not just the result of following a particular curriculum; it also demands responsibility, commitment and hard work on the part of the student. Undertaking a Foundation in art and design involves an intensive process of learning through making, collective imagining, self-analysis and critique, alongside a willingness to experiment, take risks and allow things to fail. Importantly, it is also an opportunity for self-discovery and reinvention. The emphasis from the outset is very much on developing a process that sustains further enquiry rather than on refining an outcome.

This book is intended as a sequential process to work through, rather than a set of choices to dip into. When tackling the ideas and projects set out here it is important that you open yourself up to discovering what you do not yet know. We want you to embrace discomfort and challenge rather than simply rehearse and repeat skills that you already know and feel comfortable with.

We have deliberately presented exercises that do not suggest or define fixed outcomes. This reflects how we teach: we want you to adapt rules and embrace tangential possibilities and unanticipated discoveries. You should regard the book as a provocation; an object to push against and a challenge to explore, to question and to make. From the outset we expect you to confront what it means to be an artist or a designer by testing your ideas out in the world, and in doing so attempting to clarify the purpose of your work and its potential application and impact.

We believe passionately that in a progressive society it is essential to encourage and nurture big ideas, imagination, empathy, critical thinking, problem-solving, adaptability and leadership, all of which are foregrounded in art and design education.

In showcasing examples of the incredible optimism and ambition that our Foundation students demonstrate, we hope to draw attention to the huge potential and diversity within the worlds of art and design, and the capacity of these disciplines to have a direct impact on the communities in which you live. The interviews in this book present compelling evidence of a generation of artists and designers who are building on the fundamental lessons of the Foundation course to develop powerful creative voices and careers. You too can join them.

History of Foundation

The Central Saint Martins Foundation Diploma in Art and Design at University of the Arts London has its origins in Britain in the 1960s. It was developed in response to the British government's Coldstream Report (1960), which found that students progressing from school to art college were not prepared for the level of specialism required for undergraduate study in art and design. The Foundation course, from which the current model evolved, was set up in 1966 at the Central School of Art and Design (later to merge with St Martins School of Art to become Central Saint Martins) to meet this need. The course was heavily influenced by international ideas and pedagogies, including the Bauhaus's preparatory art curriculum, the Vorkurs. The Bauhaus was an innovative school of art, architecture and design founded by Walter Gropius in Weimar, Germany in 1919. Gropius emphasised a focus on the 'creative shaping of the processes of life' rather than on objects or outcomes. Johannes Itten, who developed the Vorkurs between 1919 and 1923, promoted a holistic approach to art and design education, valuing the development of critical thinking and personality as much as technical preparation. These core values underpinned the formation of the Foundation course at Central Saint Martins, with the focus as much on nurturing the individual to cultivate their own unique creative voice as on the acquisition of skills.

Since the first Foundation courses emerged in Britain more than fifty years ago, the Central Saint Martins Foundation experience has changed, but the core principles and division of specialisms remain the same. The course still fulfils a very important diagnostic purpose, guiding students towards an area of subject specialism and supporting them in building a portfolio to prepare them for some of the best undergraduate and postgraduate courses both in the UK and internationally. Crucially, however, at Central Saint Martins, the Foundation course is an intense, demanding and transformative experience for our students. Thanks to the fast-paced projects, the high quality of teaching by art and design practitioners (all of whom are active in their field) and the emphasis on critique and reflection, over the course of the Foundation year we see our students becoming artists and designers with their own emergent visions and voices.

Chapter 1

Propose

Ideas Factory

'The project's value is not what it achieves or does but what it is and how it makes people feel, especially if it encourages people to question, in an imaginative, troubling, and thoughtful way, everydayness and how things could be different.'

Anthony Dunne and Fiona Raby, *Speculative Everything*, 2013

This project introduces you to the notion that your ideas and the ways you shape them into creative possibilities are of great value. Ideas Factory asks you to let go of any preconceptions you might have about what constitutes a beginning and an end for a project, and think instead about approaches that move beyond the traditional set of aesthetic, technical and functional values often applied to art and design.

Ideas Factory is where we begin the Foundation course because the approach to research, ideas generation and visualisation it will teach you will form the basis of your creative practice. It will help you establish strategies for research and speculative thought that you can continually return to in order to stimulate ideas and initiate work. In this project, you will explore the potential of a creative process that does not focus too heavily on practicalities and is not inhibited by perceived gaps in knowledge or skill.

As technology and globalisation slowly move us towards a more restrictive cultural uniformity, your ability to imagine radically new ways of thinking about and being in the world has never been so difficult yet so essential. In their book, *Speculative Everything*, Anthony Dunne and Fiona Raby demonstrate the tendency for design to focus on problem-solving, and call instead for designers to speculate about a new future, designing for a world that is around the corner rather than with a focus on the potentially unfixable challenges of the one we live in today.

We would like you to become an 'ideas factory' for the duration of this project, allowing your speculations to acquire value as you master the processes of research and visualisation.

The ability to visualise ideas is an essential aspect of art and design practice, and for this project, translating your personal, idiosyncratic ideas into a visual language will be central to the success of what you do. The purpose of a visualisation is to show other people the potential of your ideas by bringing them to life on the page or screen. While a visualisation often details practical aspects of the work in terms of scale, location and material, it is also a tool for representing the potential effect of the work in order to gain support for a project. Through the visualisation of your ideas, you will tell the story of your proposal, describe the context the work sits in and consider the impact of the work on its site and audience.

From the very beginning, this Foundation course asks you to adopt an expanded notion of art and design practice. We place particular emphasis on exploring the points of engagement and friction between the creative disciplines and, more broadly, within society, encouraging you to maximise the potential impact of these interactions.

Brief

Create a proposal for a piece of work, giving consideration to its conceptual basis, the material it is made from and the process involved in making it.

Accumulate a body of research and use this to inform the ideas that you will then develop into a set of possible outcomes. You do not have to make the work, so you do not need to be inhibited by practical considerations.

Through drawing and annotation you will communicate everything about your planned work. This project asks you to think broadly and ambitiously and to experiment freely.

Consider the following list of terms.
You will use these to inform your work.

Context	Material	Process
1. Connection	1. Air	1. Cut
2. Distance	2. Concrete	2. Fold
3. Tension	3. Hair	3. Suspend
4. Movement	4. Rubber	4. Expand
5. Order	5. Water	5. Wrap
6. Chaos	6. Ink	6. Knot

Step 1
Research the context

Roll a dice to select a context. Draw all the
associations that you have with the term, and ask for
further suggestions from those around you. There is
no wrong answer.

Use a library and the internet to clarify the
definition of your term and identify historical
reference points using as many sources as possible
to map out a wide-ranging list of points.

For example: **connection**

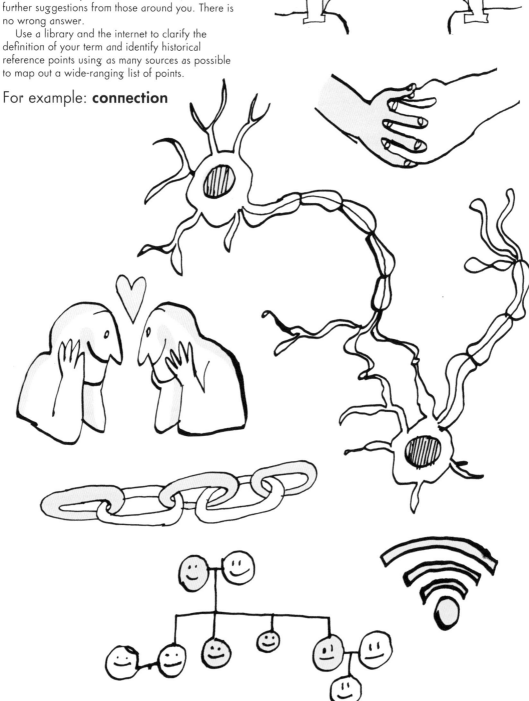

Step 2
Brainstorm the material

Roll your dice again to select a material.
 Look around you for examples of that material and list its different properties.
 Now sketch visualisations of all the associations you have in relation to your material.

For example: **air**

Step 3
Brainstorm the process

Roll the dice to select your process.
 List examples of this process and visualise through drawing its properties and associations.

For example: **wrap**

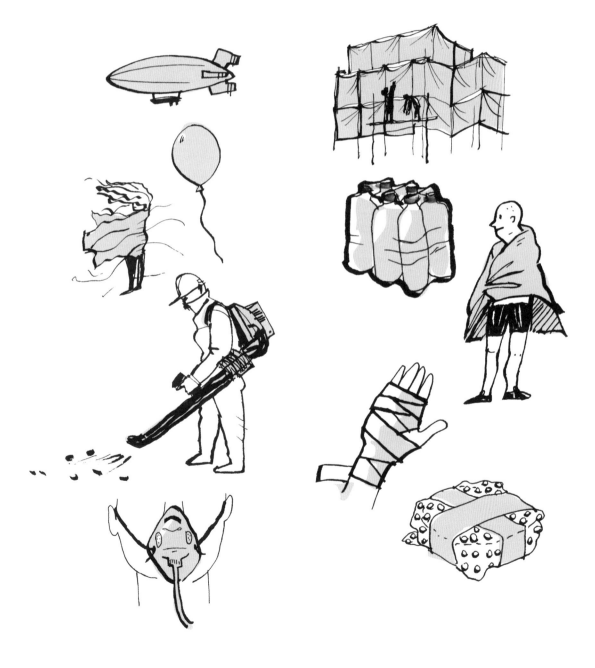

Step 4
Join the material and process

Select at random a material reference from your research and a process example. Imagine ways you could combine them. Sketch out what might result from this combination. Forget about practical or technical considerations.

For example: **concrete** (concrete park bench) and **fold** (pleated skirt)

What would a pleated concrete bench look like? Or a pleated concrete skirt for that matter?!
 Repeat this process with 10 different combinations and use line drawing and notation to represent them. Try not to overthink, and do not edit.

Step 5
Add the context

Connect the ideas, properties and forms gathered so far to explore the potential of a whole range of hybrid thoughts. What happens when you put multiple, seemingly unrelated elements together?
 For each of your 10 material and process combinations, now explore adding the context term. How can your material and process hybrid be used to express the ideas relating to the context?

For example: **how might a pleated concrete bench initiate connection with others?**

Sometimes the relationship with the context term is connected to the location chosen for the work, or to how it would be used. **(See workshop on p. 19.)**

Step 6
Select ideas and develop a visual language

Now you have some ideas for creative proposals on the page, remind yourself of your initial research and identify which of your proposals best encapsulates the concerns you feel most interested in.
 Each of your ideas will already contain clues about the ways you might visualise it. Materials have inherent properties, and each context term suggests associated materials or spaces that you might work with.

Step 7
Location

It is helpful at this stage to imagine a location for your work. The location will give you a set of restrictions and forms to interact with and design around.

Step 8
Create an A2 visualisation of your proposal

Creating the visualisation of your proposal will not simply be a process of showing what your idea looks like, but also a process of storytelling and persuasion. Clarity and simplicity are key. **(See the examples in the workshop on p. 20–1.)**

How to form hybrid ideas

A hybrid is the creation of something from two different elements. When applied to creative ideas generation this can become a method of inventing new possibilities by playing with combinations of seemingly unrelated materials, processes and concepts.

For example, by combining a helium balloon with wrapped scaffolding, you might dream up floating inflatable architecture.

If you were working with the context term connection, you might explore the way floating architecture might connect with the built environment to offer spaces for social connection and play.

Material **Process** **Context**

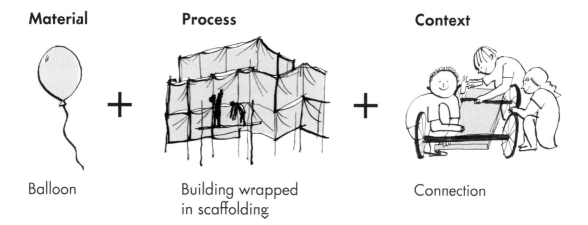

Balloon Building wrapped in scaffolding Connection

= Inflatable Architecture

How to visualise

Collage

Greek Chorus of Anarchist Drones

1

Start with the background. Describe the space in a quick, simple way using solid shapes cut from paper.

2

Use photocopied images to visualise the main elements (masks and megaphones). These are more detailed and will stand out from the simple background.

3

Use flat, round shapes created digitally or with paper (drones) in a contrasting colour to the background (in this case white).

4

Add people to give a sense of scale and space.

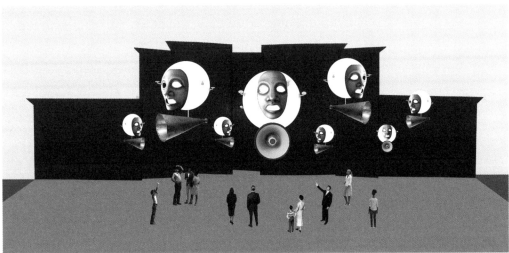

White-out photocopy

Inflatable Unschool

1

Print two black-and-white copies of the image to be intervened with.

2

Take both prints and cut out the main aspect of the image (in this case the building).

3

Paint one of the cut-out images with a white wash.

4

Glue both cut-out images to a new sheet of paper.

5

Use paper collage to add additional objects to bring the idea together (here, the tubes going in and out of the buildings).

6

Use drawing to add detail and introduce context.

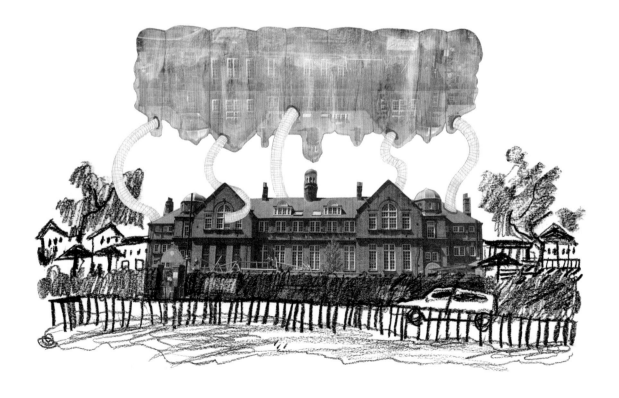

Student work

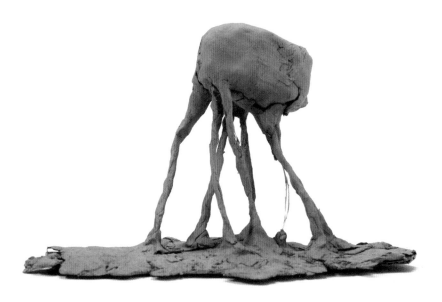

Yujing Wang (above)
Rubber + Movement + Suspend

I observed the effect of rubber melting over time when left in the sun and I wanted to use this material effect in a large-scale sculpture for a public space. The form is inspired by jellyfish whose bodies are in constant movement and flux. I was excited by the idea of a large mass precariously suspended on long tentacles.

Max King (below)
Tension + Concrete + Suspend

I envisioned my sculpture to be constructed out of concrete hanging in a large gallery space. The concrete will slowly disintegrate while suspended to represent how a large force (such as a political party or regime) can be broken down due to anarchism and rebellion. The piece is meant to appear daunting, powerful and solid as well as weak, weightless and fragile.

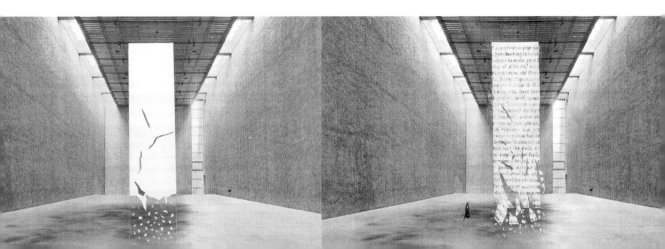

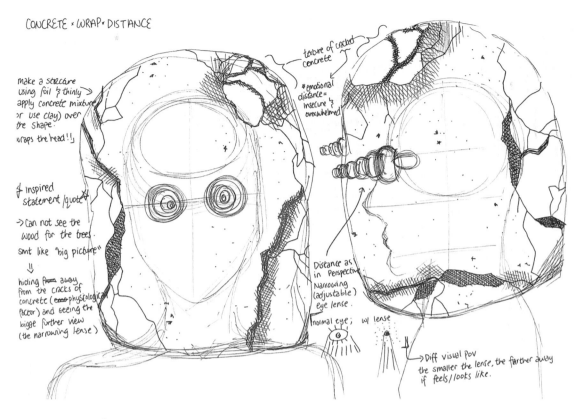

CONCRETE × WRAP × DISTANCE

make a structure using foil & thinly apply concrete mixture (or use clay) over the shape.
wraps the head!!

& inspired statement / quote

→ can not see the wood for the trees.

smt like "big picture"

hiding away from the cracks of concrete (emo physcological factor) and seeing the bigger further view (the narrowing lense)

texture of cracked concrete

emotional distance = insecure & overwhelmed

Distance as in Perspective Narrowing (adjustable) eye lense.

normal eye; w/ lense

→ Diff visual POV the smaller the lense, the farther away if feels / looks like.

Karam Chung
Concrete + Wrap + Distance

There is a saying, 'can't see the wood for the trees', which essentially warns us of the need to widen our perspective in order to fully understand a situation. By making purposeful cracks and scars on the mask to resemble concrete that covers the face, I aimed to convey this message of looking at things from a broader point of view as a means of overcoming struggles and hardships.

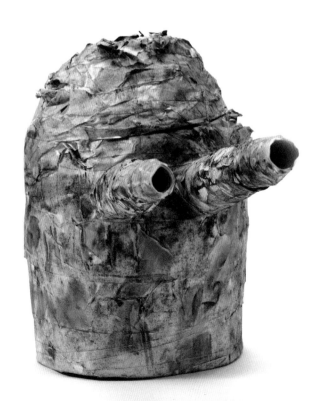

Chapter

2

Research

No work exists in a vacuum: everything you make and do as an artist or designer sits within the history of art and design and the wider world at the time that you make it. Without deeply knowing what surrounds our own creative output, we cannot assert its place in the world. Therefore, developing an in-depth research process is central to evolving a robust and informed art and design practice.

Our approach to developing a research process is threefold. Firstly, we encourage that you **think before you look**, tapping into what you already know and think about a subject before extending your exploration of it. Following this, we suggest that you **search for an original** – an attempt to form new ideas around a subject by getting as close as you can to first-hand experience of it. Thirdly, we place importance on a process where you **contextualise** what you are doing in relation to what is happening now and to what has gone before, connecting your practice to a broad range of secondary research sources. All three of these phases are outlined and expanded upon in this chapter.

Crucially, too, research does not sit outside the processes of making and doing, but is an intrinsic aspect of the evolution of any art and design project. Rather than starting a project by looking at what has gone before, a process which can stultify creative production and result in a tendency towards pastiche, start with what you know. The research process can then weave its way through your project, building towards a well-informed and fully contextualised outcome.

Research will underpin so much of what you do as an artist or designer, from gaining an understanding of your subject

matter and exploring materials and processes to considering your audience and the context in which your work will be received. The most important part of the research process is conversation: about what you think, what you are looking at, about your ideas and your ambitions for your work. It is these conversations that will open up possibilities, spark fresh ideas and take your work in new and unexpected directions.

Think before you look

In setting out to find out more about a subject, it is all too easy to type a few keywords into a search engine and allow the internet to spew forth vast swathes of ready-made information which may or may not be reliable. Or even perhaps to head to your bookshelf or a library to access books and journals on a topic. We favour another approach first: what you already know and have direct access to is an ideal starting point. You are working to develop your own unique visual language that reflects your view on the world. Find ways to expand your own knowledge, memories, interpretations and experiences before you look to information from secondary sources.

Exercise: Blindfold discussion

This is an exercise in trusting your own initial feelings, thoughts and responses. It is also a way of extending your research base, accessing the knowledge of people around you to enrich and inform your own thinking on a subject. In taking away your sense of sight, you are removing visual distractions and the tendency to focus on the reactions of others. It is a way of initiating a different type of conversation around a subject.

You will need to be in a group of three to five people and you will each need a sleep mask or a piece of fabric to tie around your head as a blindfold.

1. Define the topic for discussion

This could come from a project you are working on or it could be any subject that you are interested in and would like to explore in more depth.

2. Put on your blindfolds!

It can be good at this point to each speak about how it feels to have your sense of sight removed. This allows everyone to get used to the sensation and to feel comfortable talking without seeing.

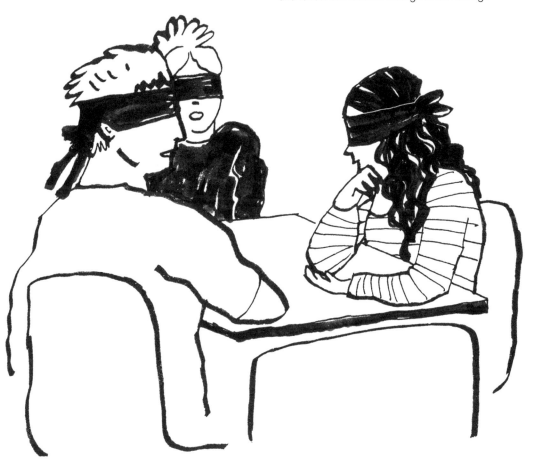

3. Discuss

Your discussion should last around 10–15 minutes. Organise your discussion around the following questions:

- **What do you know about the subject?**

- **What have you experienced or come across that has a relationship to the subject?**

- **What visual images or associations does the subject conjure?**

4. Reflect

Replay and reflect upon the discussion. What did you find out that you didn't already know? What did you hear that you would like to find out more about? Could any of the visual associations be interesting starting points?

Search for an original

As you initiate project work, we always encourage you to actively search for new information and ideas that you can then use to fuel the creation of an innovative body of work. Think about this process as a search for an original – a thought, idea, image or piece of knowledge – that you have ownership of and are fully invested in. It may not always be possible to find something completely new, but it is the drive towards it that is valuable. This is an active process, involving going out into the world and engaging with what you find there. It is also a process that will rely on interactions with others who can contribute their knowledge.

Exercise: From one to another

This exercise offers an alternative way of initiating a research process and finding a starting point for a project. It requires ingenuity and persistence, asking you again to draw on resources close to hand – friends, associates, experts in your wider social network – and not the impersonal, indiscriminate search engine.

For this exercise you will work with one of the images on p. 29. You are simply asked to source another image (drawn or photographed) that relates to the one you assign yourself. The aim is not to recreate precisely the image you are looking at; instead you will find or construct a new image that will hold its own story. The gap or point of friction between the image at the start and the image at the end is what is of interest and has creative potential.

Pay close attention to the following rules throughout this activity:

- **Do not use an internet search engine**

- **Do not use a library or access books/ printed materials**

- **Have conversations with people in person, on the telephone or via email, text or social media**

- **Source all imagery and information via your network of contacts.**

1. Select an image above to work with

Brainstorm your initial thoughts about the image. What do you think it is? Where do you think it could be found? Does it conjure any specific memories or associations?

2. Expand your understanding

Think about who might be able to help you expand your perception of the image. Be ambitious and try to think beyond your immediate personal and professional networks. Is there someone you follow on Twitter or Instagram who might provide insight or opinion?

3. Discuss

Discuss the image with three people who you think will be able to provide information, interpretation and insight. You can do this in person, over the phone or via email or social networks. Ask them the same questions that you asked yourself in step 1.

4. Source a new image

Based on what you learn from your conversations, find a new image. Will you ask one of your contacts to help you with this? Or, with the information you now have, do you need to find your image elsewhere?

Examples

A fish

A student tasked with finding an image that related to the image of the fish realised that it was 9pm in Tokyo, meaning her friend would be eating at a local seafood restaurant. She phoned the friend and asked her for an image of her dinner.

An abacus

This reminded an Argentinian student of her childhood abacus. It was 7am in Buenos Aires but she decided to call her mother and ask her to find and photograph the object.

A clock

A student decided that this image resembled the clock at London King's Cross station. After messaging his network of friends he found someone close to the station and convinced them to take the photo.

Now you have your starting point. You have been involved in a process of discovery that has led you to a new image with its own story, which can suggest a beginning or a new direction for your work.

Contextualise

Having asked you so far to work only with what you know or have direct access to, we now want to give you some strategies for making sure that your work is fully situated within the context of existing art and design practice and is well informed in relation to its subject matter.

Visit museums and galleries – you may target exhibitions or collections that have a clear and direct relationship with what you are interested in. However, it can be just as fruitful to look at work not explicitly connected to your subject matter.

Go to the library or a bookshop – books and journals are of course a great source of information and knowledge. Again, browsing the shelves of a bookshop or library can be just as beneficial as searching a library catalogue for books directly related to your subject.

Use the internet – the internet can give you access to a vast wealth of valid information. It is important to use it carefully though and it should be only one of a number of secondary research methods that you employ.

Set up a blog – This is where you can locate your secondary research and record your response to your selections. Create an analytical commentary that might include your thoughts on subject matter, material, process or scale.

Chapter

3

Draw

Sketchbooks are fascinating; they are a window into an artist's or designer's mind, revealing their unique way of looking at or thinking about the world. However, the sketchbook has become a much fetishised object featured in countless books, blogs and social-media accounts showcasing stylised and curated examples that few can emulate. It is no wonder that at some point on the Foundation course every student articulates anxiety or frustration over their own sketchbook: *it's too big, too small, too messy, too contrived, I can't draw, what's it for?*

So why do we work with a sketchbook and what is it really for?

Your sketchbook is primarily a place to draw and think. By working in your sketchbook regularly and methodically you can develop a visual language that is distinct and personal yet also adaptable. It's a place where you can wrestle your ideas into the visual field so that you can begin to better understand their potential and turn them into creative action. The only way your ideas can create impact – be provocative, seductive or even disruptive – is by making them visible. Your sketchbook initiates this process. The act of exploring here drives your work forwards. It is where you take risks, make mistakes, explore alternatives and generate solutions.

Drawing, in its widest sense, is fundamental to your creative process. When Brassaï asked Picasso if his ideas came to him by chance or by design, Picasso replied: 'I don't have a clue. Ideas are simply starting points...To know what you're going to draw, you have to begin drawing.' Drawing is a process of discovery: first, as a discipline of looking and recording, and

second, as a way of thinking as you integrate, adapt and play with your initial reference points in a process of design. Successful drawings are therefore exploratory: they should surprise you and help you make observations and think through ideas. They are the raw potential that should excite further drawing or making.

But drawing is difficult! Drawing is slow! If I want to record something I photograph it on my phone.

When Alberto Giacometti compared his drawing process to 'the gesture of a man groping his way in the darkness' he was acknowledging that gesture prefigures language and that drawing is able to cast light on things you don't yet understand or cannot articulate. While photography can be an important tool, drawing is a more effective way to explore experiences and abstract ideas and to be surprised and stimulated by the possibilities that start to appear on the page.

Aside from being a tool for drawing and developing ideas, your sketchbook is an active space where you can explore the potential of materials and processes and where you can think about your audience or user. As you work in real time and integrate swatches, mood boards, material tests and mockups with your conceptual concerns, your sketchbook will chart the journey of a project from inception through to completion. There are as many different ways of using a sketchbook as there are artists and designers in the world, and if you allow yourself to work instinctively and freely, your sketchbook will help you develop your visual language.

If you believe in and trust your ideas, it follows that you will want to explore every possible avenue to making them visible. If pursued relentlessly and with rigour, this process provides the means to put ideas to the test until they begin to fly or alternatively become exhausted and give way to new ones. Working in your sketchbook requires energy, determination and fearlessness to move towards what you don't yet know.

Interview
Ignacia Ruiz, illustrator

Ignacia Ruiz is an illustrator and designer born in Santiago, Chile, who works primarily with drawing and printmaking. She lives and works in London and is an Associate Lecturer at Central Saint Martins on the Foundation Diploma in Art and Design.

Henry Nelson O'Neil
THE LANDING OF HRH
THE PRINCESS ALEXANDRA
AT GRAVESEND.

How do you use a sketchbook?

I carry it everywhere with me and I am not afraid to make mistakes in it. I use it as an image bank where I store observations to pull from later on. It is the most direct route between my brain into the 'real world'. In it I capture things so that they remain fresh in my memory.

Sometimes the sketchbook itself is the 'finished' work and sometimes I use it to consciously plan something.

How does your 'image bank' inform your work and why not just use a camera or the internet?

The reason for developing your own image bank is mainly so that you have your own personal references. I prefer drawings to photographs because when you draw something you can get to know your subject. The more I draw, the more I know what key things to get down quickly before the person or thing moves on. When drawing from a photograph it is easy to get bogged down in

focusing on details and end up with a contrived drawing that you have laboured over for hours.

The more you add to your image bank the more you retain in your memory and therefore you begin to learn how to draw things without looking at them in life.

Things you draw have been filtered through your eye, your brain and your hand so now they inevitably and unmistakably look like you made them.

For me it is also a bit of a compulsion and something I need to do. It's a way of making sense of the world around me. When I capture something in my sketchbook I feel like I make it mine, it's been added to my bank. It's a lot like collecting objects. I can go home with Greek marble statues or a castle if I have it in my sketchbook.

You are a successful illustrator, yet you still go out and draw each day. Why?

Because it's an ongoing process that never really ends. I also think that to stop drawing would be to say that I have reached the pinnacle of my work, and that is far from the truth. I don't think you should ever stop learning and trying things out. Drawing outside is sometimes associated with 'student work' but I think it is an essential practice for an illustrator.

And at the beginning of your freelance career was drawing part of how you built a sense of practice?

I think work comes from work and to keep things ticking over you need to be producing or working on things constantly. It might feel a bit aimless at times but that's when you have to trust the process, to invest in it.

It also gives you a bit of control over what you want to get commissioned for or the type of work you want to make.

How did you establish your visual language and then develop it?

I think it happened mainly through repetition and the confidence that came through drawing daily. At the beginning, every drawing in my sketchbook felt like a risk until, through doing it a lot, it felt like there wasn't such a fear of failure anymore. That's when I started to experiment and find my own way.

When I started out my work was almost all in black-and-white ink and a lot more detailed than it is now. Eventually I started using colour.

I don't think I ever had a eureka moment where I said 'THIS is my visual language!' It was more of a gradual realisation that I had an accumulation of images that had started to feel cohesive.

What role does your sketchbook play in pushing your practice forward and generating continual discovery?

The sketchbook is where all (or most) of my raw material originates and where I can be very playful. This usually doesn't happen with commissioned work, where there might be little room for experimentation. The sketchbook is where my stupid ideas get aired and breakthroughs are born (and also where disappointments and failures happen!).

The sketchbook is my way of collecting 'data' that then gets channelled into projects. With an archive of sketchbooks I feel like I never start something completely empty-handed, so there's less room for fear of a blank page.

Instagram: @ignacia_rz

Interruptions for lazy looking

Lazy looking is not really looking at all. It is when we guess or approximate things. When you really interrogate what you are looking at and challenge yourself to use and invent a wide range of approaches to capturing what you see, your drawings will start to reflect your unique way of looking.

Exercise: Character and scene

1. Character

- Observe one person, grasping their main characteristic. What is the first thing you see?

- Make your drawing, keeping in mind your initial observation and capturing three additional elements: posture, pattern of clothing and key features (for example glasses, hairstyle).

2. Scene

- Consider the whole image as an abstract pattern.

- Start with a line drawing, capturing what is nearest to you first.

- Add blocks of colour and then alternate adding detail and colour, depicting the rhythm and energy of the mass.

Exercise: Black and white and colour

1. Black-and-white crowd

- Build up the group as a series of shapes.

- Identify an equal proportion of positive and negative shapes. The whole picture should fit together like a puzzle.

- Use a brush pen to fill in the areas of black.

2. Colour

- Begin by making a line drawing, placing a main character in the centre of the page and then organising additional elements around them at the same scale.

- Add a flattened background using a repeated pattern element to collapse the picture plane.

- Select four contrasting colours. Start with the lightest colour and apply it to big and small areas of the image. Use the second darkest colour for the background.

Henry Nelson O'Neil
THE LANDING OF HRH
THE PRINCESS ALEXANDRA
AT GRAVESEND.

Exercise: Detail and expression

1. Double-page cityscape line drawing

- Using a calligraphy pen, place in the main vertical shapes and then the horizon line.

- Add in shapes across the image using fine lines to connect elements.

- Using a fat line, bring out key details and foreground.

2. Double-page landscape using a brush pen

- Imagine a frame around the area you want to capture.

- Decide on the two main textures you want to represent and then choose a gesture for each.

- Begin at the bottom of the page and work your way up, adding in some bold horizontal marks to ground the image and describe the perspective.

Exercise:
Collecting and abstracting

1. Quick sketches
of isolated objects

The aim is to be able to own the thing by drawing
it and taking the drawing home.
 Use line drawing to capture how it looks
and add notation to remember key information.
These sketches become part of an
archive or image bank.

2. Observing
and abstracting

- Observe a plant. Zoom in and crop until
 you are not seeing the whole form.

- Using a thick black crayon, capture the
 key shapes, making sure they interlock.

- Add three contrasting colours that are
 not related to what you are looking at.

- Add in the background using a rough mark.

Remember you are not drawing the plant – you are
merely borrowing shapes or pattern from the plant.

How to develop ideas, with Ignacia Ruiz

The following guides are some of the approaches I have developed as an illustrator to capture the unique qualities of what I am looking at and to expand my visual language. Try them out and then adapt them as a way of developing your approach to drawing.

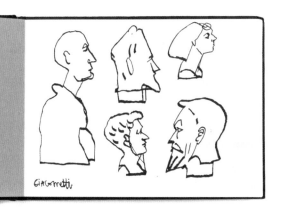

Turn ideas into three-dimensional experiments

Drawing helps you to think, to work something out and to understand the potential of your ideas. If you repeatedly draw an idea from different angles and in different ways, you can gain a better understanding of it and how it could be constructed or developed. This allows you to start turning drawings into three-dimensional pieces or physical experiments.

Change the scale

One of the ways I use drawing to investigate and experiment with my ideas is through a change of scale. Deciding to enlarge scale inevitably makes you think about what materials you might use to transform your ideas.

Make your own tools

When drawing at a large scale I often try to invent and fabricate suitable tools using things you wouldn't initially associate with drawing. For example, I might use sponges and charcoal but also rocks, branches and mud.

When working at a larger scale, your whole body becomes engaged with your idea and this can also lead to innovation in your work.

Chapter

4

Make

'If you have something in mind that you think you are going to do, the chances are you are going to get to the studio and it doesn't happen, but something else may do, and it's that sort of irregularity that I depend on in which the work begins to instruct you and you learn what needs to be done from the materials instead of imposing on the materials what you want done.'

David Batchelor, quoted in Ian Dawson, *Making Contemporary Sculpture*, 2012

As you begin to identify your own practice and discipline, you will need to explore different materials and the processes by which you can manipulate and work with them. Wherever you end up situating yourself, investigating the properties and potential of your materials will form a significant part of your creative practice.

On the Foundation course, we embrace the idea of the studio as a laboratory. Through a process of experimentation and play, we encourage you to explore a wide range of materials, helping you to discover what new forms, functions and meanings you can invent with them. This might involve repurposing unconventional or found materials that would otherwise be thrown away. Or it could mean applying craft skills to manipulate conventional materials into new structures and forms.

Ordinary household waste, second-hand shops and the general debris found on the street are frequently embraced as free or inexpensive sources of materials that can be brought into the studio and transformed. Sometimes the material will sit in a corner for a while until an idea emerges, at which point it will be given new meaning and form through experimentation and play. Technical workshops facilitating woodwork, metalwork and casting are also vital spaces that offer opportunities to transform raw materials into works of art or design.

Material value

While your choice of material can be influenced by matters of practicality, process or tradition, you will find that the material itself also frequently carries the very concept and meaning of the work. A particular material could facilitate interaction, challenge convention or revive sensory memories, rituals and traditions. Time and again we see how the artist or designer's use of a carefully selected material can invoke powerful stories and start conversation and debate.

When the Tate Gallery in London purchased Carl Andre's layer of house bricks (*Equivalent VIII*, 1966) in 1972, there was outrage among sections of the press and public who refused to consider its value as anything other than a building material. New approaches to materiality have subsequently transformed the way people engage with art and design by manipulating unconventional materials to create challenging multisensory experiences.

For example, in recent years Parisian fashion brand Coperni used Fabrican's sprayable, liquid fibre to spray a dress onto the body of Bella Hadid at its Spring Summer 2023 show at Paris Fashion Week. In 2020, designer and professor at MIT Media Lab, Neri Oxman presented *Silk Pavilion II* at the Material Ecology exhibition at New York's Museum of Modern Art. The piece was made by a swarm of 17532 silkworms and a robotic loom as a prototype of nature-centric design.

As this kind of innovation and play with materials continues to produce new and amazing works and products, society shifts its ideas about value and desirability. Even the ways we deal with death have now been affected by new applications of materials and technology, from eco-friendly coffins to diamonds made from a loved one's ashes.

> 'Our desire for intrinsic value and connectedness has driven the way for new interpretations of materiality, as opposed to merely applying materials as an afterthought.'
>
> Chris Lefteri, quoted in Jenny Lee, *Material Alchemy*, 2014

Sustainability

As the world reaches a crisis point, one of the most urgent demands on you as an artist or designer will be to ensure that your practice and output addresses issues of sustainability. Your work will need to take into account climate change, the availability of raw materials, the potential recyclability of waste

and the impact of single-use plastics. This might involve integrating the latest materials and technology into your practice or responding to the ethics surrounding sourcing and production. Increasingly, the fields of research, technology and design are becoming more integrated; artists and designers can take advantage of the opportunity this offers. As more sustainable materials are developed and waste products repurposed, it is the role of the designer to imagine uses and applications that transform these new materials into a more environmentally responsible output.

'For me design is not about making another chair or another lamp. Good design, good luxury is not about a Louis Vuitton bag or a Ferrari, it's about clean air, clean water, clean energy.'

Daan Roosegaarde, in interview with *Dezeen* for their Good Design for a Bad World project

Designers will have to work hard to convince consumers to set aside their current luxury products and replace them with plastic-free or repurposed alternatives. The creation of desirable forms and powerful new stories may ease this transition. From Adidas football shirts made of recycled ocean plastic to an Ai Weiwei art installation made from discarded life jackets, successful art and design integrates invention and desirability with the power of the material's original story.

Notions of value – economic, political, societal, environmental – are at the heart of these narratives. In Weiwei's work made from refugee life jackets, the material has a devastating human narrative that the artist reframes with sensitivity and care. In the case of the Adidas football shirts, the sustainability of the fabric confers social and environmental value on the product, but is really only of value to a footballer if it also works on a functional and aesthetic level.

Meaning and metaphor

Perceptions of a material's value, its associations and meanings are hard to shift, but art and design are uniquely able to change perception through adjusting context and viewpoint.

Picasso's throwaway remark upon noticing surrealist artist Méret Oppenheim's fur-covered bracelet that one could cover anything in fur prompted her to cover a tea cup, saucer and spoon with the fur of a Chinese gazelle. What interested her was the idea that if you alter a teacup's materiality, this in turn alters the viewer's perception of what that teacup is. The resulting work, *Object* (1936), is both attractive and disturbing – sensual to the touch and repellant to put in the mouth.

Oppenheim's *Object* demonstrates a unique understanding of the practical, emotional and sensual aspects of materials. The challenge for you is to put investigation and play at the heart of what you do. Alongside developing an awareness of technological developments and historical traditions, this can move you towards a practice that presents a message of sustainability to your consumer or audience.

Interview
Phoebe English, fashion designer

Phoebe English's pieces are entirely made in England from start to finish. Garments are created with a close attention to detail, fit and movement. This focus on precision and quality aims to set the label apart from mass-made 'fast' fashion.

What is your approach to selecting and sourcing materials for your work?

My work stems from chance. This is also true of my material choices, which come from chance conversations, chance findings. The deciding factor is whether or not I have an instant connection to it when I see or touch it. If it isn't an instantaneous thing, then it tends not to work out. You have to be prepared to drop it if it doesn't want to come to life, so to speak.

What informs your approach to experimenting with, crafting or manipulating materials in your practice?

Communication. I am constantly trying to attain some kind of communicative tension between the materials and surfaces that I employ. I do this in several ways: exploring scale, inside out, upside down, destroyed, perfectly finished, dark, light, fine, clumpy, static,

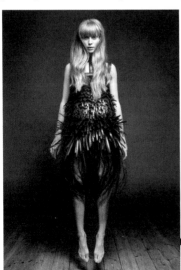

dynamic, etc. Trying to achieve some type of visual conversation, contrast or tension with the materials and how they are used will eventually inform the silhouette they are embodied within.

How do materials inform the meaning or concept of your work?

The connotations a material holds are very important to me and are key to how I use it. I am often recreating an 'old fashioned' textile technique and reimagining it as a contemporary piece of work. As techniques, they often have 'crafty', 'grandma' or 'fusty' connotations, so I have to take this into account when selecting a material to render them in. Playing with scale and material is the most efficient way to reinvent these textile techniques. Remaking a piece of trench art into giant knotted skirts, using stretchy power mesh in place of old boot laces, reinterprets the intricate knotting technique of the original piece.

How do you approach the relationship between materials and their perceived value?

It's a case of experimenting, playing and making plenty of mistakes (the bigger the pile of mistakes the better the textile ends up being). Trying, failing and trying again to see where you can push the material and the form. Taking things apart, putting them back together, breaking them, mending them, enlarging them, shrinking them until you get to something that strikes you. This may not be immediately perceivable to most people, but it's what I find is often the difference between whether someone will stop and look at something or not.

Instagram: @phoebeenglish

Interview

Alix Marie, artist/photographer

Alix Marie is a French artist/photographer based in London. Her practice merges sculpture, photography and installation. Her work explores the relationship between the body and its representation through processes of objectification, fragmentation, magnification and accumulation.

How do you define and situate your practice?

I have two practices: one in sculpture and one in photography. I could never choose between the eye and the hand, between seeing and touching. During my studies I started to think of the photograph as an object. I wanted to take it out of the frame on the wall and create bodily, sometimes visceral experiences.

Why do you use such a wide range of materials?

I have always experimented with a wide range of techniques and materials, rather than choosing a specific medium to master. It fascinates me that today the photographic image can be printed on any medium, and I often take inspiration from mundane applications of photography: printing a picture of your kids on your bank card, duvet cover or mug, etc.

What informs your approach to experimenting with materials?

I constantly test things out in the studio and do not necessarily know when these tests will develop into a project. What I really try to keep in mind during every step of the process is that content and form go together, so the material choices have to be linked to the work conceptually and metaphorically. I also leave plenty of room for mistakes during the realisation of the work. I like to see how materials react and how I feel about them before I decide which aspects of my work to push further.

Can you describe the development of a piece of work?

Orlando is a large-scale installation composed of large-scale prints of close-up body parts of my lover. The photographs have been dipped in wax, crinkled, scanned and reprinted, resulting in a trompe-l'oeil effect, skin trying to break open and escape itself. The cracked wax resembles marble, the marble of meat and the marble of classical sculptures.

Orlando comes from an investigation of how to represent intimacy, those moments where the other's body is blown up through proximity and every detail of the skin and body unravels. I have always felt teased by the similarities between skin and the photographic print: both surfaces, both fragile, both ungraspable.

Instagram: @afnmarie

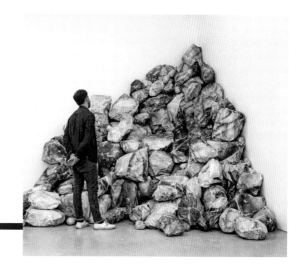

Exercise:
One material many forms

This exercise challenges you to use a can of expanding foam to make an interesting form. The aim of the task is to explore the unpredictability of the material and to find a way to apply your own interests to the material's inherent aesthetic.

William Davey

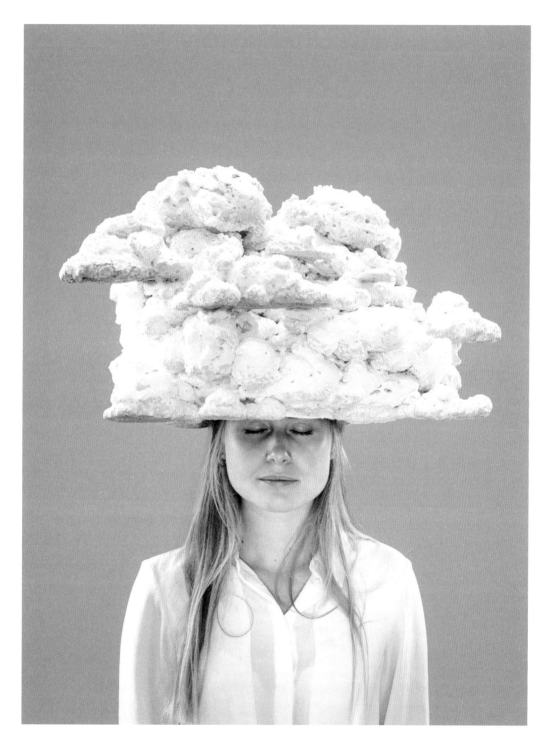

Tobias Collier

Exercise: Making meaning

This exercise challenges you to change a 10cm² cube of wood by adding one material or applying one process to it. The aim of the task is to find innovative ways to use material and process to change the way we read the wooden block in terms of its aesthetic, meaning or use.

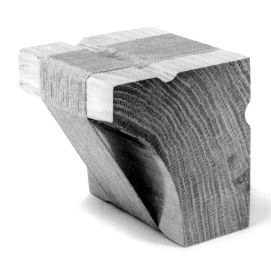

Birgit Toke Tauka Frietman

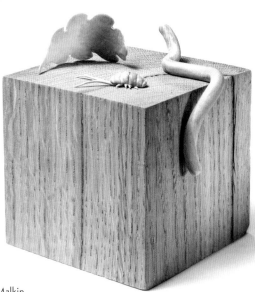

Nicola Malkin

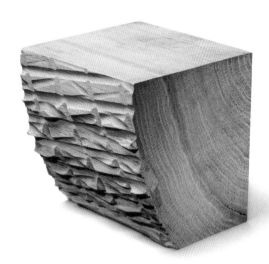

Mark Laban

Barry Lillis

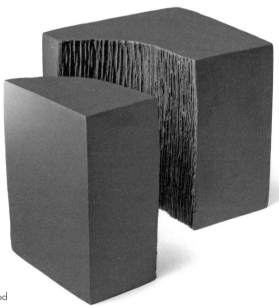

Emma Peascod

Chapter

5

Reflect

Why reflect?

As you undertake the projects in this book, you will work in ways that are unfamiliar to you and search for materials and situations that you are not fully in control of. Your instinctive responses to these challenges should lead you towards the areas of art and design in which you have the greatest potential for creating impact.

The value of completing the projects lies not only in the outcomes you will produce, but also in the acquisition of skills that will help your process of creative enquiry become fruitful and self-sustaining. In order to learn from your experiences, you will need to look critically at what you are doing – at your behaviours and decision-making – from a variety of perspectives. This process is called reflection.

Art and design practice involves an iterative process: you return time and again to key decision points, exploring a number of potential directions. Reflection is a key part of this process of analysing backwards and planning forwards, helping you not only to refine your working process but also at times to destabilise it by introducing experimentation.

Develop a practice whereby you write reflectively at regular stages throughout a project. The aim of this reflective writing is to understand what you have done so far and why you did it that particular way. Effective reflection will also help you to isolate what is and isn't working in your project, to recognise working practices that you need to challenge and to plan what you will do next (reducing the opportunity for stress and anxiety).

It doesn't matter whether your writing finds form in a notebook, a blog or a series of Post-it notes. What matters is that it should be concise and easily integrated into your daily art and design practice.

Another effective way to work through creative problems is through conversation. Talking through an idea or a work in progress with someone else often brings clarity and triggers fresh thoughts. This is not necessarily because the person you are talking to provides a solution, but often because as you hear yourself speak, you start to understand your work in a different way.

Reflective questions

By asking questions of yourself at key stages of a project you can develop a formalised process of structuring your thoughts and moving your work forward when confronting moments of uncertainty. A good reflective question is one that forces you to analyse the relationship between things: for example, between your concept and material, or your chosen metaphor and the context you are working in, or your preconceptions of an activity and how you approach it.

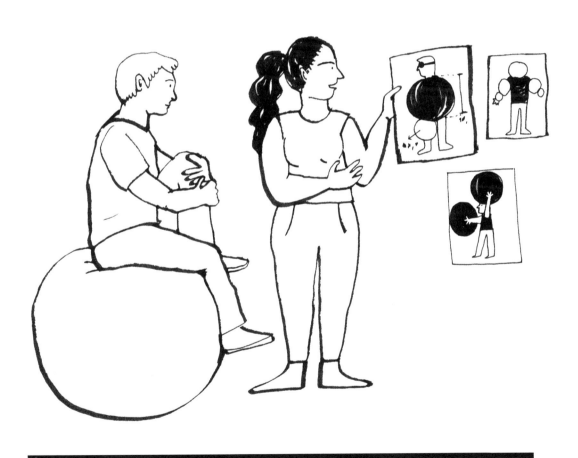

Exercise: Analyse a piece of reflective writing

In the following example of a daily reflection, the graphic design student is working with the metaphor of the cocoon and the concept of leaving traces. The work being discussed is part of a wider exploration of the relationship between presence and absence.

 1. Identify the moments of discovery in the process being analysed.

 2. Identify points where key decisions are being made.

Words in circles

'Because of yesterday's experiment with writing on fabric, I wanted to continue working with text. My initial idea was to build a cocoon with letters and words. I thought of starting with a small circle of text in the middle of the paper and layering bigger and bigger circles on top of it. In my head, the viewer was looking into the cocoon built from letters from above. As I started layering the text in circles, I thought that text layers didn't really become three-dimensional, but because of the circles the text became a sort of movement, which I thought was very interesting.'

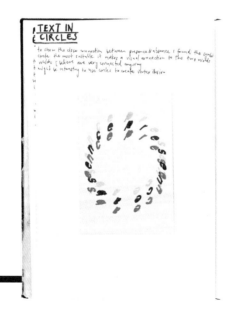

Julia Luckmann

'I experimented using screen-printing to print the text, but the letters overlapped too much and were too small and so I decided to continue by printing them digitally. I'm still not sure what the final outcome for this project will be and therefore I have decided to show it to my tutor to gain new ideas for how it could be developed further.'

This student's reflection is effective at looking backwards and clarifying what the experiment is achieving so far. It isn't so successful at identifying a next step that would maximise the effects she has discovered. Introducing a consideration of audience and context can help you decide where to go next with your work. The following set of questions suggests a way forward for the student in the example above:

- **How and where might a viewer encounter this work?**
By imagining a context for the work, you assist yourself by introducing specific requirements and restrictions dictated by the location.

- **Is it situated on the floor, on the wall or in space?**
The idea of a viewpoint brings into play decisions about material, scale and interactivity.

- **Is the work intended to be temporary or permanent?**
This question guides your choices of media. For example, if you wanted to explore a process that was temporal then the work could be a projection, which would support the notion of presence and absence. If the work was intended to be permanent, then you might laser-cut or etch it into a stable material.

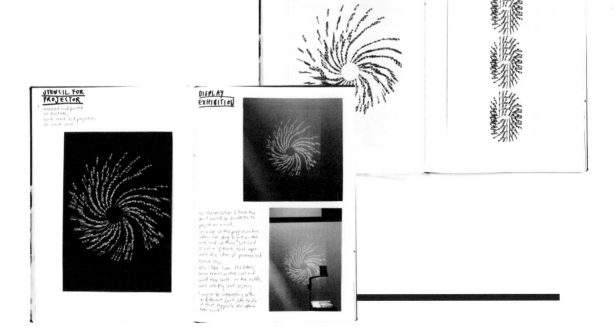

What is analysis?

Within an art and design context, analysis involves identifying what an output is doing or saying and then testing it against a set of aims or values. These can be functional, aesthetic or theoretical. Sometimes they will be established by a brief or a client, and sometimes they will be self-determined.

A good starting point for analysing a piece of work is simply to state what you see in front of you. By describing the work as it appears, it soon becomes apparent what aspects of the work are communicating clearly and where the points of uncertainty are. Next, you can ask yourself questions, such as: what does the object or image make me think and feel? What does it remind me of? Does the work make me want to touch or interact with it? These personal and subjective responses offer vital information, and the greater the honesty in your interpretation, the more value it has. You can analyse your own work in this way, but it is also hugely important to regularly invite others to undertake this for you. Ultimately, the success of your work will be determined by how effectively it communicates to others – inviting critique on what you are doing as it progresses can therefore be very beneficial.

What is success?

As you experiment and make intuitive decisions, you will need to frequently assess your progress against a clear set of intentions. Once you have identified an idea of success, then your reflective writing will provide you with a safety net, giving you confidence in the decisions you make and the rationale you are applying.

For each test or image you make ask the question: what is that image or test doing? More questions follow, such as: is this the desired effect or something I can embrace? If yes, how can I maximise this effect? If no, which element of the image or test is most problematic? This is not a science, and what ensues is often a process of trial and error as your work goes through multiple iterations on its journey towards resolution.

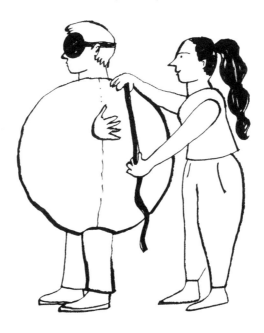

Exercise: Define success

This is an exercise in acknowledging your decisions and experimenting with them to generate alternative solutions. By learning how to generate multiple possibilities, you can more easily define for yourself a notion of what constitutes success.

Step 1

Do a one-minute drawing of a car on a blank piece of paper.

Step 2

Identify three decisions that you made in completing that task.

Step 3

Try to identify why you made each of those decisions.

1. Drew both wheels first to determine scale of drawing.

2. Drew the car's 'body' in one continuous line.

3. Drew details inside the car such as windows, doors, etc.

1. Drew the details first in blocks of black (windows, lights).

2. Drew wheels as two solid shapes.

3. Drew the car's outline to bring all the elements together.

Step 4

Do a second one-minute drawing of a car on a blank sheet of paper, this time applying three decisions that differ from those you made in your first drawing.

Step 5

Identify the differences between the two drawings and consider how those differences are related to the decisions you made each time.

Step 6

Which drawing is more successful and why?

Reflecting forwards

Reflection involves not only analysing what you have already done, but also creating a plan for what you will do next and developing strategies for its successful implementation. Reflecting forwards requires you to connect with your responses and feelings in order to consider the effectiveness of your strategies, often while they are in action. Thinking on your feet critically and strategically like this enables you to recognise problems as they arise and to intervene accordingly.

'What do I do next?' can be a difficult question. Almost always, it is more productive to make or do something rather than to think philosophically through a problem. It is very easy to get caught up imagining ever more fantastical solutions that only present you with more problems or reasons why you can't create work. A crude or quickly made test realised with whatever is at hand quickly moves you away from 'what do I do next?' to the all-important and decisive question 'how do I develop this?' By trusting in a process of reflection leading to action, you can avoid an unproductive search for that illusory perfectly formed idea.

Chapter

6

Risk/Fail

67

'If you experiment, you have to fail. By definition, experimenting means going to territory where you've never been, where failure is very possible. How can you know you're going to succeed? Having the courage to face the unknown is so important.'

Marina Abramović, *Walk Through Walls: A Memoir*, 2017

In the early stages of the Foundation course at Central Saint Martins, students learn to take risks and open up to the possibility of failure. The challenge of the diagnostic process leaves no space to labour on a task in search of perfection. Instead these projects demand agile decision-making and an exploratory approach to making and doing.

Putting aside your own judgement of your work (the internal voice that tells you whether something is 'good' or 'bad') is at the heart of the journey towards becoming an artist or designer. Johannes Itten, founder of the Bauhaus's preliminary course (see p.9), advocated a process of 'unlearning' for his students, where the aim was to shed the practices and attitudes of their prior education and begin again with a 'blank slate'. While we value previous experience and welcome diversity of educational background, there is enormous potential in challenging yourself to push your practice into areas that are unfamiliar and perhaps uncomfortable for you. Creativity thrives on difficulty, challenge and conflict.

Our projects frequently ask you not only to fail but to fail in public. Since a consideration of audience informs how you conceive and make your work, it is important that you test your output in a public context. Circumstance, timing and other unpredictable factors mean that your work may not always be received by others in the way that you expect. You will need to incorporate a system of testing and revision into your work, and inherent to this process is a degree of failure. Only when things don't function as they are supposed to will you be able to take the steps necessary to making them a success. There is always the possibility with everything that you do that it might collapse or it might soar and it is this fine line between success and failure that we encourage you to walk.

Interview
Lizzy Deacon, artist

Lizzy Deacon and Ika Schwander specialised in fine art on the Foundation course at Central Saint Martins. Both developed a practice involving performance and live elements. Here Deacon talks about their collaborative project, *FUCKSAPIENS*, outlining how her attitude to risk and her acceptance of failure has become a defining aspect of her art practice.

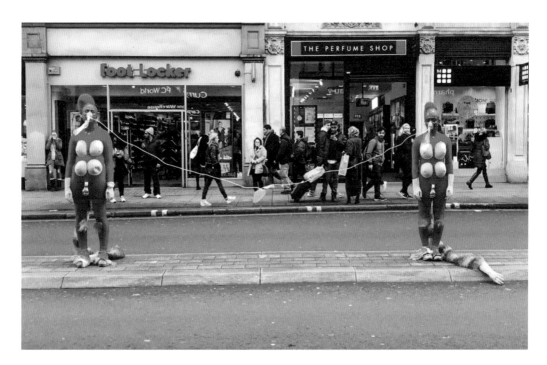

Can you describe your performance piece?

FUCKSAPIENS was developed with my friend and fellow student Ika Schwander in response to a disued aviary in a park in North London. We were interested in exploring the relationship between human beings and animals and as part of our research process we watched Pier Paolo Pasolini's film *The 120 Days of Sodom*. There is a particular scene in the film where people are imitating dogs attached to leads and begging to be fed by their 'owners'. This made us think about the complex and hierarchical relationship between human beings and animals, and in turn we created the Sissy species, which is caught somewhere between the two. Sissies are red-skinned, four-breasted and long-

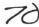

limbed with hundreds of eyes and light bulbs for genitals. In our performance, the Sissies moved through the city carrying out their daily activities of feeding, cleaning and reproduction.

What motivates you to want to make work for a public, 'non-art' environment?

It is always interesting to get reactions from people who have little or no expectation about what they are going to see. In some ways, I respect their opinion of my work more than people who 'know what they're talking about'. They tend to say exactly what they think, rather than what they think they should be saying. I would like to say that my work doesn't depend on people's reactions, but it does. Reactions help define my work.

Can you talk about how you deal with notions of risk in your performance work?

I believe my ability to take risks is what defines my work. I have become resilient to failure and do not mind 'losing' or not fitting in. However, I do not view failure as a 'loss', because it forces me to look at other options, ones I may not have otherwise considered. During the creation of *FUCKSAPIENS*, we had what we thought at the time were setbacks. These occurred as a result of the risks we had taken. We pushed the boundaries of what was appropriate in the context of our project, and as a result were forced to reconsider our performance plan.

During a performance that by its very nature was out of your control, how did you make decisions about how far to push some of your intentions?

In our initial performance plan, we understood and had accounted for the unpredictability of performing. The lack of control we had over performing to a live audience would give us the freedom to improvise – something that excited us. If anything, being out of control would mean we could fully explore the narratives of the characters. A lot of what happened during our performance was not planned and occurred in response to the situations we found ourselves in. In the end, this is what we think made the piece successful.

Can you talk about how you define success and failure in your work?

In simple terms, success is when I am happy with something I have made and failure is when I am unhappy with it. My definitions of these words follow years I have spent conditioning myself to self-validate and not rely on others to do this for me. Failure is just as important to me as success; without failure, I feel I would not understand success.

Instagram: @lizzydeacon

How to take risks and embrace failure

Set out below are twelve one-hour exercises which offer strategies for making works that invite and welcome the positive potential of risk and failure.

Exercise 1: Explore the boundaries of taste

Identify something that you think represents bad taste and then make a work that embraces it.

Exercise 2: Take your work out into the street

Place a piece of your work out in the street. Find a way to situate the work in a way that will encourage people to see and engage with it. Stand back and observe your audience's reaction.

Exercise 3: Make work without an idea

Play with a material repeatedly until something happens. The moment a concrete idea emerges, stop and start again.

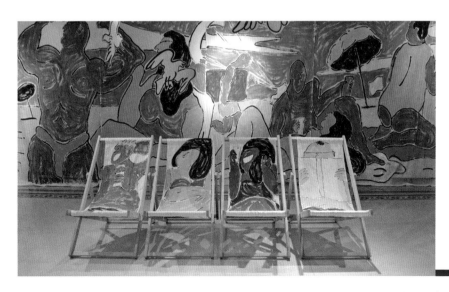

William Davey, *Riccione Deck Chairs* (in response to Exercise 1: Explore the boundaries of taste)

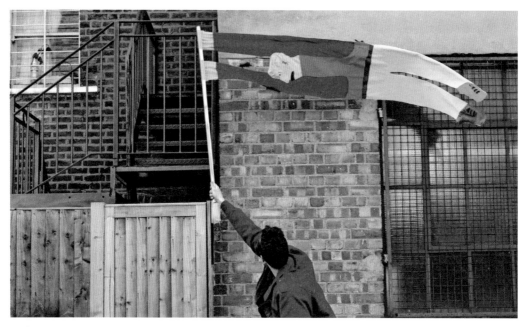

William Davey, *Man Flag* (in response to Exercise 2: Take your work into the street)

Exercise 4: Make work without using any materials

You are your own tool. Your body gives you access to a language of gesture and movement. Use it.

Exercise 5: Make a work out of space

Explore graphic designer Alan Fletcher's statement that 'space is substance'. Design a space in which your audience can think, imagine and reflect.

Exercise 6: Make a drawing exploring repetition

Dancer and choreographer Pina Bausch said that 'Repetition is not repetition...The same action makes you feel something completely different by the end.' Use a repeated action for one hour to make a drawing.

Exercise 7: Identify the rules of photography then break them

Choose one rule and plan a way to break it, for example, not looking through the viewfinder, or placing something in front of the lens. Go for a 30-minute walk, taking at least 15 photographs applying your rule-breaking method. Repeat the same walk several times, choosing a different rule to break each time.

Exercise 8: Explore Duchamp's notion that 'destruction is also creation'

Find a broken or second-hand item and deconstruct it into its constituent parts. Now use those parts to make something else.

Exercise 9: Make your own tools

Using simple materials, make a set of tools that allow you to make original marks. Use them to create a series of drawings.

Exercise 10: Confront your fears

Marina Abramović asks her students to discard ideas they like and work with ideas they discard: 'Because the trash can is a treasure trove of things they're afraid to do.' Explore your own fears by returning to some of the ideas you have previously thrown out or dismissed.

Exercise 11: Embrace the obvious

Investigate artist William Kentridge's notion of a 'necessary stupidity'. Identify the most obvious, literal solution to a problem and run with it.

Exercise 12: Look within to reveal what you see

Identify aspects of yourself that are hidden and uncomfortable and find a way to wear them.

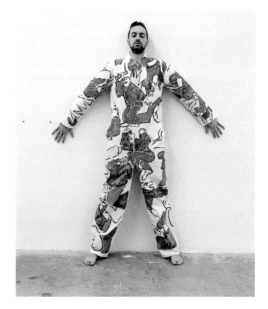

William Davey, *Suit* (in response to Exercise 12: Look within to reveal what you see)

Chapter

7

Explore

The projects in this book are divided into three sections, corresponding with the three stages of the Central Saint Martins Foundation course: part 1: diagnosis, part 2: situating practice and part 3: the self-directed project. During the diagnostic stage students typically undertake twelve projects, varying from one day to one week in length, over a nine-week period. These projects are designed to explore each student's different aptitudes across the main areas of art and design.

 During the diagnostic process, the emphasis is placed on immersing students in the demands of each project rather than differentiating subject areas or learning skills. The disciplines that the student is most drawn to at this stage are not the key driver for diagnosis, since this can often be clouded by the student's preconceptions. Instead, the ways in which students respond to each project and the work they produce becomes the evidence we use to begin guiding students towards the subject areas where they can achieve greatest success.

 We have selected five diagnostic projects that cover some of the core themes of creative practice. For this diagnostic process to work, you will need to attempt all of these projects with an open mind and suspend judgement of the work you produce until the whole sequence of projects is complete.

Image and Narrative

This project explores visual language and narrative. It stems from the discipline of illustration but addresses skills of composition, layout, semiotics and economy of form that are fundamental to other design fields. The particular challenge of this project is the limitations it sets out. It will test your ability to respond to restriction to craft a compelling visual narrative.

Context

Illustration is the visualisation and interpretation of ideas, concepts and information, and it also works as a means of expression. Reflecting society and shaped by what surrounds it, illustration takes diverse forms and exists in a variety of mediums from drawing to printmaking, and from digital to three-dimensional works. It is a vehicle that sheds light on diverse topics and makes them accessible to everyone.

As an illustrator, you will be required to work with restrictions given to you by a client, and within this framework you will need to develop a visual language that is easy to understand yet also presents a layered and rich narrative. The search for an image, message or sign that is at once universal and distinctive is one of the central challenges of communication design.

A lost letter

Letterpress was a revolutionary relief-printing technique developed by Johannes Gutenberg in the fifteenth century. It worked with a system of movable type whereby wood, and later, metal letters could be locked into the bed of a printing press. This allowed multiple copies of a manuscript to be printed before the letters were rearranged to create another text. This process changed the world, allowing knowledge, information and ideas to be distributed far more quickly and economically than had previously been possible. The letterpress technique has gained renewed popularity thanks to its tactile nature and the possibilities it creates for typographic experimentation. It is common to find the wood or metal letter remnants of antique, disbanded typefaces in antique markets and online. These lost letters are beautiful when printed, but separate from their alphabets they have lost their original function and can no longer be used to spell whole words.

When you hold a letter in your hand and examine it from different angles you can appreciate its form, explore its unique character and enjoy the patination acquired from years of use. To a visual communicator these qualities will immediately suggest other possible meanings and uses.

Colour and style

The use of red as an accent colour alongside black and white plays a significant role in the history of graphic design and illustration. There is both an economic and a semiotic reason for this. Firstly, it would have been cost-effective to restrict design to these colours. Secondly, red is a strong colour that immediately draws the eye.

A powerful visual style consisting of clean lines, pure shapes, flat colours and formal order in graphic design has carried from early twentieth-century Bauhaus through to Swiss design of the 1950s and 1960s. It still resonates in contemporary graphic design and illustration.

This project will confront you with a fundamental aspect of communication design: the process of taking complex ideas and narratives and distilling them into simple and direct communications. It will also introduce key design skills, asking you to consider the organisation of the space of the page, the relationship between text and image and the application of colour.

Brief

This project challenges you to transform one thing into another by developing a simple and direct visual language that communicates through playfulness, humour and sleight of hand. It is a short introduction to the discipline of illustration, and the steps will show you the possibilities of combining type with image or using type as image. Your task is to create a screen-printed image that transforms a printed woodblock letter into a visual story, pattern or character using only red, black and the white of the page.

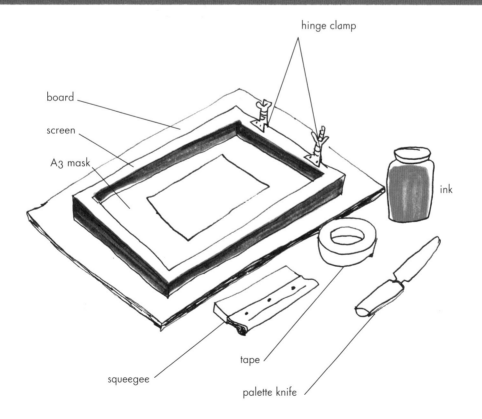

hinge clamp

board

screen

A3 mask

ink

squeegee

tape

palette knife

Step 1

Make several photocopies of the letterform (p. 77) in this book onto A3 cartridge paper. You will use one of these as your starting point and one as the master copy onto which you will develop your design. The remainder will be used to print your final design onto. If you wanted, you could also find and print your own woodblock letter.

Step 2

Turn your photocopied letter around to see what it suggests from different angles.

What are its characteristics? Does it have a solidity or suggest movement? Does it have a prominent curve?

Step 3

Look at the letter in relation to the white space around it. The texture of the printing might start to suggest a night sky or a view through a window.

Fill a page of your sketchbook with pencil line drawings of the characters, narratives or patterns suggested by your letterform. Do not edit your ideas or eliminate the obvious. Remember there is no such thing as a bad idea.

You will not be able to move the preprinted letter on the page, so your designs will need to fit around the letterform in order to make a composition. The most successful compositions will consider the whole space of the page, explore background and foreground and will fully integrate the letterform with the screen-printed element.

Step 4

Select one idea and draw it to scale on an A3 sheet of newsprint. So that you match your printed letterform exactly, trace around it using a window or a light box.

When your design is drawn to scale, mark the parts that you want to print in red and the parts that you want to print in black.

Note: It is best to colour the letterforms in red and black pen to help with tracing and clarity.

Step 5

Trace only the red parts of your design onto a new sheet of newsprint. This will form your red stencil. Repeat this process for the black parts of your design to create your black stencil.

Note: When tracing, make sure you line up the paper accurately at the corners so that your red and black printed layers will align.

Step 6

Use a scalpel or craft knife to cut away and discard the areas that you want to print red and then the areas that you want to print black. The holes in your stencil will be where the ink will transfer through the screen and onto your final prints. You now have two newsprint stencils to use for your screen print.

Note: In cutting out your stencil, you might end up with floating pieces that are no longer joined to the main part of your stencil. Keep these!

Step 7

Line up the letterform with the A3 mask on your
screen and then place your red stencil on top of
your letterform, lining it up carefully.

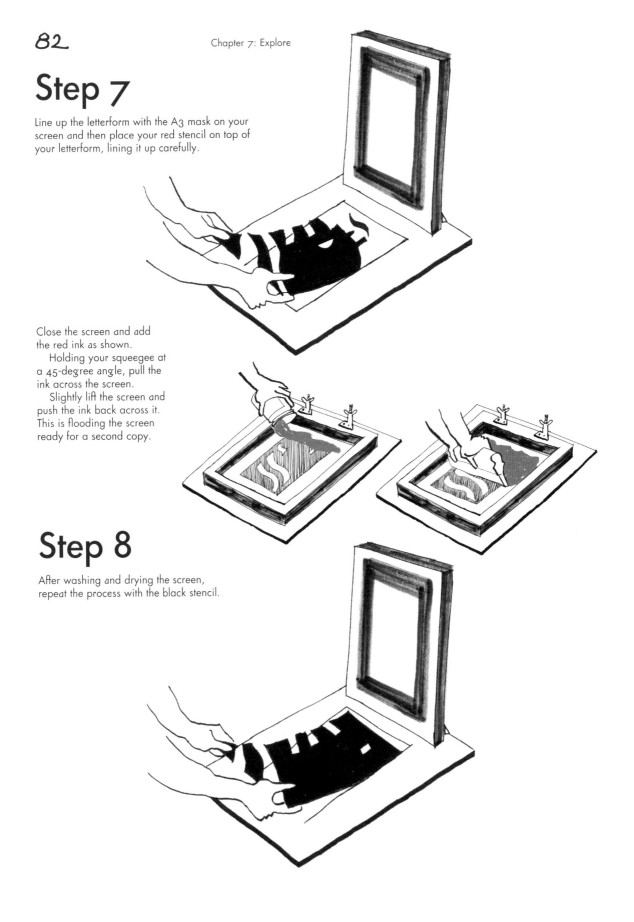

Close the screen and add
the red ink as shown.

Holding your squeegee at
a 45-degree angle, pull the
ink across the screen.

Slightly lift the screen and
push the ink back across it.
This is flooding the screen
ready for a second copy.

Step 8

After washing and drying the screen,
repeat the process with the black stencil.

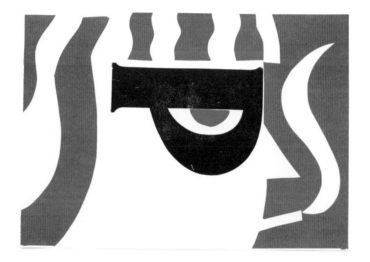

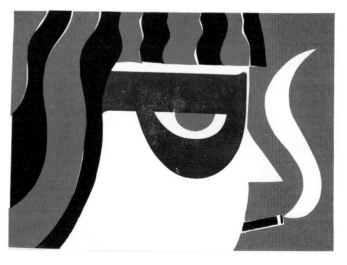

Student work

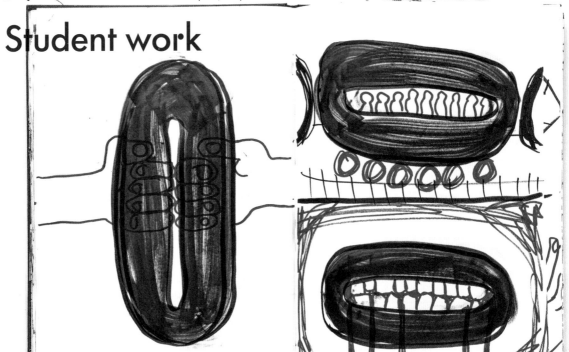

Natsuki Hanyu

Maharu Ota

Yvette Jeong

Natsuki Hanyu

Shi Yu Chai

Fan Gu

Lily Pichon-Flannery

Yinuo Chen

Rowena Potter

Siyi Chen

Cara Lloyd

Xinting Duan

Roxanna Parker

Yujie Bai

Callista Manning

Body and Form
Co-author: Jo Simpson

This project is an introduction
to form and the body. It will
reveal your conceptual ability,
your craft skill and your approach
to drawing. Whether the concept
leads the form you create
or you are thinking through
making, your approach will
offer diagnostic clues.

'I want to rethink the body, so the
body and the dress become one.'

Rei Kawakubo, quoted in US *Vogue*, March 1997

Context

A fashion designer expresses their ideas on the body, which is at the centre of everything they do. Ideas are developed through draping on the figure and through observational drawing used to capture and refine that experimentation.

Fashion design is an innovative activity where new ideas develop as much from self-reflection and an engagement with social, cultural and political issues, as from an awareness of the fashion industry itself. Designer Hussein Chalayan talks about his clothes as compositions of his ideas which, when filtered through the body, become more alive. Constructing ideas on the body through a constant play of forms, textures and colour leads on to a consideration of how use, movement and context transform those ideas further.

Silhouette

The silhouette refers to a garment's overall shape. Understanding silhouette, form and structure will help you master key design concepts in fashion design. All fashion designers have to consider silhouette; for some this becomes the main focus of a collection.

Rei Kawakubo's collections for Comme des Garçons have repeatedly challenged the way the silhouette is constructed. Her highly influential Spring–Summer 1997 collection, *Body Meets Dress, Dress Meets Body*, attempted to redesign the body itself by creating bulging padded forms on the hips, back and shoulders. This reimagined ideals of beauty and conventions of wearability. Kawakubo's Autumn–Winter 2017 collection, *The Future of Silhouette*, again dramatically distorted the form of the body with huge cocoon-like sculptural forms encasing the wearer in cardboard, insulation and carpet fabrics.

Fashion house Viktor&Rolf has also produced key examples of innovation with the silhouette. For Spring–Summer 2010 it presented tulle garments in sculptural forms with holes and sharp angles hacked into them by a chainsaw. Their project acknowledged the importance of this kind of innovation by focusing on the design of structures for the body derived from references that are traditionally unrelated to fashion or the body itself. It also encouraged the development of new approaches to the use of materials and construction.

Drawing

Drawing is of fundamental importance to fashion design and this project encourages you to embrace drawing as a tool to integrate your concerns into a design process. As a fashion student, you will spend most of your time exploring a range of design/development processes – all involving drawing – before attempting to construct a garment; pattern-cutting and garment construction are only introduced once you have learned to articulate your visual language and research through drawing and experimentation.

 This project introduces a simple strategy for translating observational drawing into unique structures on the body. The characteristics of your work evolve from the choices you make – from what you look at to how you observe your surroundings. You will use observational drawing to inform decisions about scale, form, material and construction. You will begin to understand the language of silhouette as a process of sculpting on the body to exaggerate, restrict or disguise. You will then explore how these processes can change how the body feels, behaves and is articulated.

Natsuki Hanyu

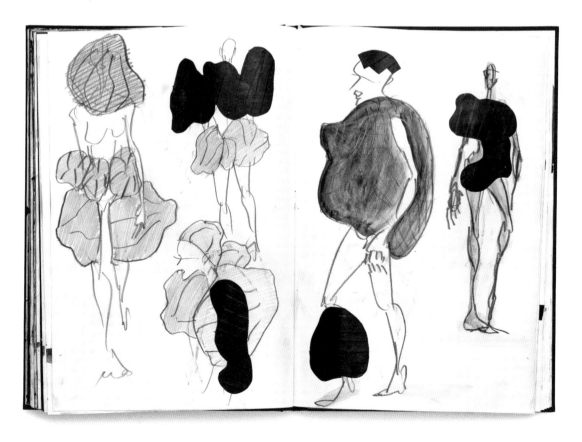

Brief

Design a silhouette or structure that will be worn on the body and is inspired by the built environment.

Begin by generating a wide range of observational drawings that isolate architectural structures, forms and textures. Carefully consider how you feel about these structures, their purpose, location and 'essence', and use these notions to inform your drawing by using a range of marks, scales and drawing materials.

By isolating a vocabulary of shapes and scaling them up, you will create paper forms that you can drape and construct on the body.

Your outcome will be a series of drawings and photographs which show your exploration of silhouette, as well as a simple garment constructed in fabric.

Step 1

Identify a building that you have access to that has a character, form and aesthetic you find interesting. Using various drawing media, make ten two-minute observational drawing studies of the structure, shape and form of the building.

Step 2

Using your observational drawings, isolate key shapes that recur in your sketches.

Overlay tracing paper on your drawings and with a sharp pencil, draw each shape separately.

Select the three most interesting shapes from the tracing paper and transfer these back into your sketchbook.

Step 3

Scale up your three chosen shapes x16 onto a large roll of paper (approximately A0 size) and cut out the shapes.

If you have access to an overhead projector you can use this as a means of scaling up your shapes accurately by projecting your small original traced paper shapes onto larger sized paper.

Step 4

Join the three shapes with masking tape at the edges.

With masking tape, you are able to make seams by joining up all or parts of your paper forms, depending on how you want your shape and structure to evolve. You can easily create volume and folds depending on where you place the masking tape.

Using masking tape also allows you to experiment with your joins, as you can easily assemble and reassemble your shapes.

Step 5

Explore draping by pinning the shapes of paper onto the body and trying a range of potential silhouettes. Think about where these voluminous shapes best fit – turn them upside down, and use them on the top half, bottom half, front and back of the body.

Repeat steps 4 and 5 until you are happy with the form and placement of your structure.

Step 6

(See How to draw the figure on p. 96.)
Make a series of two-minute observational drawings of your chosen silhouette using various drawing media. Ensure that you include the full figure in your drawings to describe the scale of your structure.

Now document your silhouette on the body using photography, capturing all angles – the front, back and side profiles.

Step 7

Sourcing the correct fabric for your structure is key. The colours of all fabrics used for this project must be neutral – this is because the focus should be on the silhouette.

Materials such as thick felt, PVC, cotton drill and neoprene all hold their shape well and provide similar qualities to those of your paper structures.

Refer back to your initial observational drawings and source fabrics that relate well to your chosen building. For example, you might use a thick felt fabric to emulate concrete or a shiny PVC fabric to reference glass structures.

Step 8

Take apart the three paper shapes from your final structure and pin them onto your fabric. Draw around the shapes before removing the pins and paper. Using sharp fabric scissors, cut out the shapes from your material, then reassemble them using pins or simple fastenings.

There is no need to sew for this project as you might find a more experimental way of joining the seams together. Refer back to your detailed observational drawings for inspiration on fastening ideas. For example, you could use punched holes along the seams fastened with metal rings to represent circular windows.

Step 9

Photograph the silhouette on a body from all angles – the front, back and side profiles.

An interesting way to analyse the silhouette you have created is to make a simple shadow screen. This can be done by hanging a thin cotton bed sheet or roll of tracing paper in a doorway and using a desk lamp to cast a shadow. You can now place your model up against the screen to create a sharp silhouette to document from different angles without the colour, texture or construction of the garment being visible.

How to draw the figure, with John Booth

The following guides to drawing the figure detail my particular approach to fashion illustration. Try them out and then adapt them as a way of finding your own system.

Things to consider

1

Think about filling the whole page with your figure.

2

Start with the head and work down. This allows you to exaggerate or elongate aspects of the figure as you go.

3

Draw with confidence, using a continuous line to prevent a broken or stuttered line. Try to work quickly and spontaneously. Don't rub out!

4

Observational drawings are a tool to start the design process, so adding colour and texture that is not necessarily present adds value to the drawing.

5

Choice of colour can be based on your research and needs to be considered as a reflection of the figure's attitude or energy.

6

Mixing media in rotation creates a range of marks to add interest. The choice of media can also reflect the weight or help describe the detail of the fabric.

7

When drawing the face, don't over-complicate and be careful not to make it the focus of a drawing.

Technique 1

1

Using gouache and ink, paint blocks of colour representing the main shapes of the body and garment.

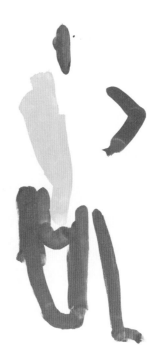

2

Draw the outline of the garment in graphite stick and water-soluble crayon.

3

In marker pen, add some of the main details of the garment, paying attention to its main forms and where it connects with the body. Finish by adding the face, feet and line of the legs and arms.

Technique 2

1

Draw the outline of the body and garment
in graphite stick and marker pen using
a continuous line.

2

Add blocks of colour and texture in marker
pen and graphite stick.

3

Add details in graphite stick and pen.

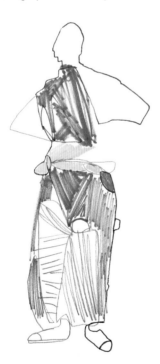

Student work

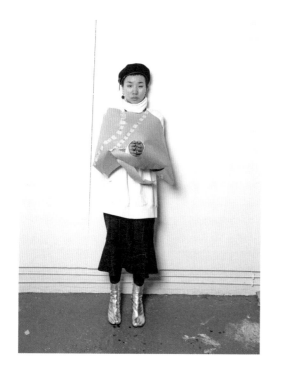

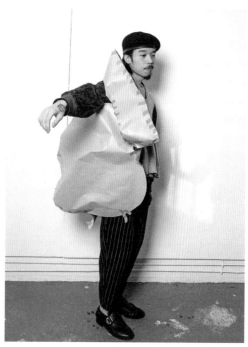

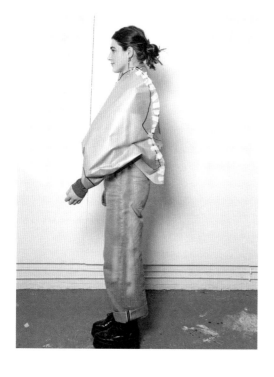

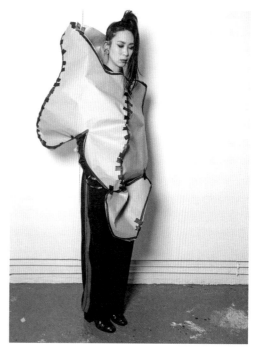

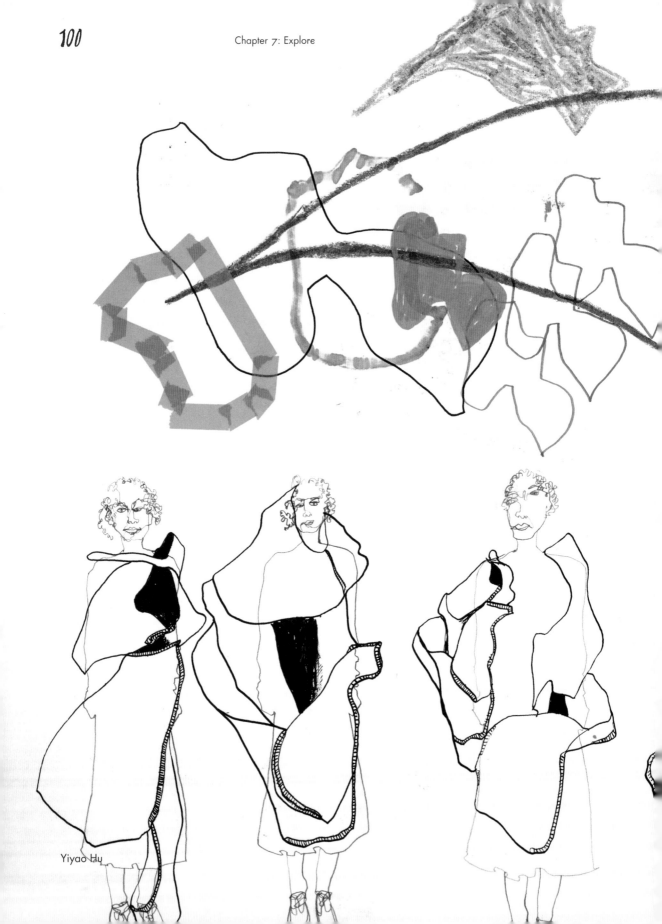

Yiyao Hu

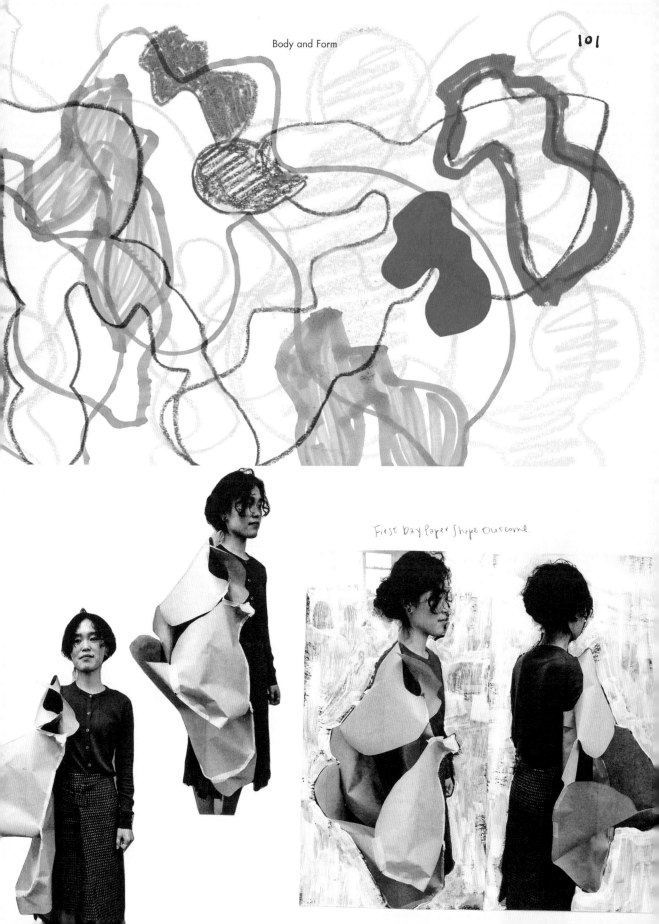

First Day Paper Shape Outcome.

Surface and Meaning
Co-author: Gary Colclough

This project focuses on perception, the deconstruction of an image and the surface of the picture plane, and it is centred on the discipline of fine art painting. It demands an intensive exploration of your unique way of looking at and thinking about the world, which is vital in any discipline. The consideration of surface and abstraction is also a feature of photography, textile design and illustration.

Left: Maisie Barnes
Above: Chater Paul Jordan

Context

There is a long tradition within fine art of artists making images that reimagine the world and our place within it. Many contemporary artists working with these themes find the abundance of visual information in the world a rich resource to work with. They exploit the potential in the found as much as the made and choose to work directly with images from an ever-expanding range of media platforms. These artists explore how translating, reworking and recontextualising images can open up imaginative new possibilities.

Using found imagery (such as old photographs, or images sourced from old magazines or newspapers) as a means of developing a subject for a painting is also a well-established strategy. For many artists though, the translation of source material into painting is not simply a process of making a copy, but a more experimental and dynamic activity. They use a variety of processes (which can include collage – both physical and digital – transfer and print) to manipulate and reconfigure found images before resolving their work through painting.

The painter Adrian Ghenie, for example, uses collage to create unsettling images which often bring together apparently unrelated objects and spaces. For him these associations create connections that bypass a rational interpretation and act like physiological symbols. The artist Julie Mehretu creates seemingly abstract paintings featuring overlapping images and marks referring to charts, maps and architectural features in an attempt to compress various aspects of a modern dynamic city into a single painting.

This project encourages, but doesn't necessitate, making a painting in the conventional sense. It takes the position that painting is not limited to the production of an object (a painting) but is a language that can be expressed through a range of materials and processes.

In this project you will learn about the importance of selecting image sources by building your own collection of images. You will begin to identify how meaning and subject matter can develop out of a working process. As a fine artist, the starting point for your work has to emerge from your own interests and concerns. Going forward, the techniques you are taught in this project become a strategy for initiating and developing your work.

Brief

This project is centred on representation and image-making and specifically on the possibilities of depicting altered or imagined spaces. You will explore the potential of working with found imagery to create a work that represents a fictional space.

The space you represent could be:
- An idealised or utopian space, or its opposite, a dystopian space
- An interpretation of a space that exists in the world
- A space that doesn't exist in the physical world that could be virtual, remembered or imagined
- A bringing together or collision of different spaces or worlds

You will use collage as a starting point to develop your ideas and create a body of work by exploring processes such as image-transfer, painting and sculpture. Your outcome will not be predetermined: it could be a painting developed from your experimentation, but equally it could be a collage, print or something three-dimensional.

The steps in this project can also be thought of as experimentation points. Each step gives you either an approach that can be used in different ways or a choice of approaches that you can select from according to how your own ideas are developing.

Step 1

Collect a range of printed source images inspired by your interpretation of the brief – these could be photographs, images from books or magazines, or printouts of images from the internet. Collect more images than you think you will need so that you can be selective.

Step 2

Experiment with how these images can be altered and combined to create new spaces and fictions. Aim to produce a series of speculative works (between three and six) trying different techniques. Even small adjustments to an image can produce radical differences, so try starting with simple changes and combinations before moving to more complex alterations. For example, initially combine just two images, or cut up and rearrange an image so that nothing is added or taken away, only reconfigured.

Step 3

Look at the collages you have made and select the most interesting and exciting ones. How can you experiment with your selected collage or collages to push your ideas further? Play with different elements, such as scale, dimension and by mixing media – what happens if you combine your image with an object or introduce paint or other mark-making materials?

Support

You can paint on any surface that will accept paint. Consider whether a conventional support (canvas, wooden panel, paper) or another material such as plastic, plaster or glass is most appropriate.

Format

Many supports come rectangular as standard, but is this the right format for your ideas? Could a circle, triangle or irregular shape be more suitable?

Colour palette and tone

Consider ways you can play with the colour palette and tonal range when making your painting.

Where to begin

The blank canvas can be challenging and intimidating. You can reduce this pressure by working quickly, painting over the whole surface with a colour, or by creating a series of marks or a pattern. Now you can begin your painting.

Where to end

Deciding how to arrive at an outcome is not always straightforward. Sometimes the experiments and sketches you have generated as part of your development process can be interesting in their own right. If this happens, it is completely valid to think about what steps you might need to take to make these become outcomes in themselves. Sometimes, it is as simple as experimenting with presenting these works in a particular way – hanging them on a wall, placing them on the floor – or realising you need to produce more of them since they work best as a collection. You could find yourself with alternative outcomes for this project, which could include drawing, photography, digital imagery, collage, sculpture and projection.

Step 4

The processes you have explored should have transformed your original images into new, unexpected forms, which you can interpret and use in a variety of ways. Selectively transfer elements from the new images you've made into a painting.

Student work

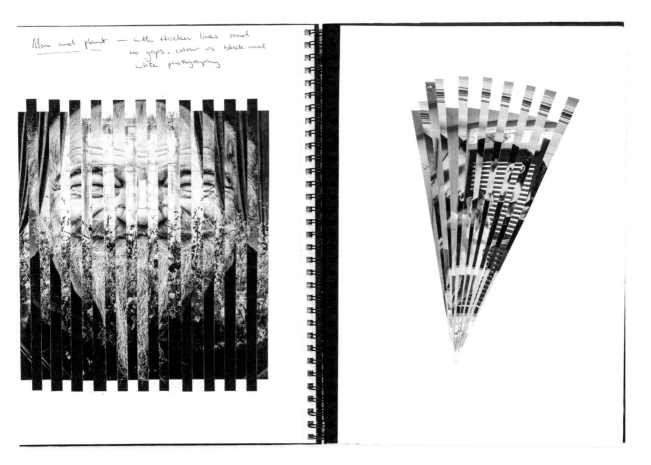

Above: Luke Ridley

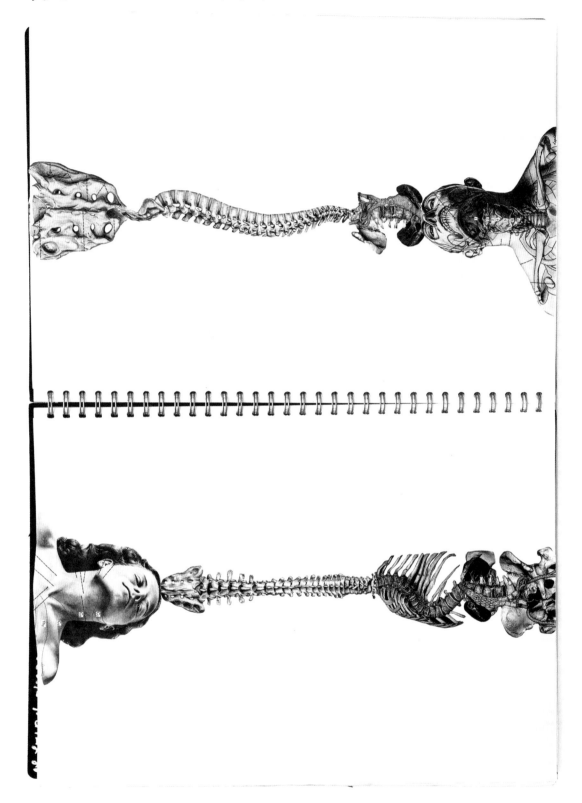

Maisie Barnes

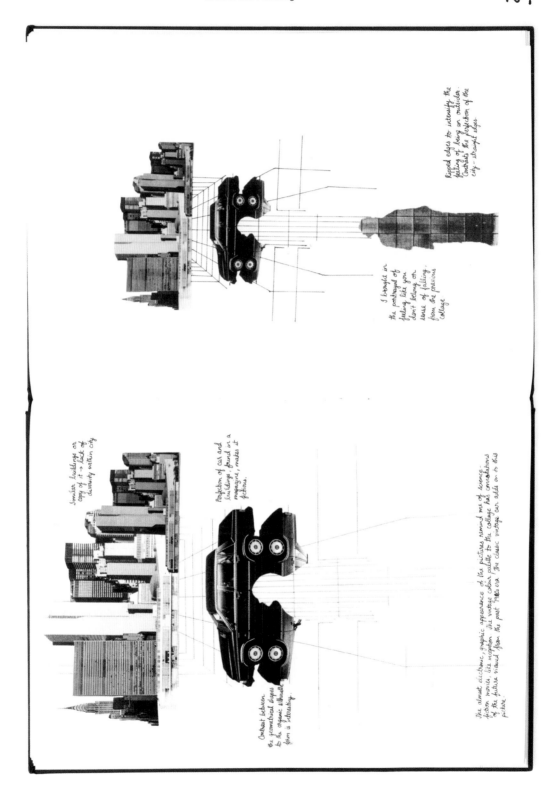

The almost electronic, graphic appearance of the pictures remind me of science-fiction movies. Its inception, the vintage colour palette to the collage had connotations of the future viewed from the past 1980s era. The classic vintage car adds on to this picture.

Projection of car and buildings, found in a magazine, makes it fictious.

Similar buildings or copy of it → lack of diversity within city

Contrast between the geometrical shapes to the organic silhouette form is interesting.

Ripped edges to intensify the feeling of being an outsider. Contrasts the projection of the city - straight edges.

I brought in the portrayal of feeling like you don't belong or sense of falling from one previous collage

Maisie Barnes

Patrick Dougherty

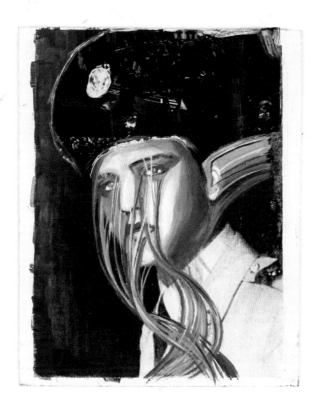

Sun Min Kim

Space and Function
Co-author: Alaistair Steele

This project is rooted in the discipline of architecture, with its consideration of space and structure. However, the brief is an ideal diagnostic tool since the way you instinctively choose to approach the construction of forms, their scale and surface, could reveal potential function-ality as jewellery, a garment or a product.

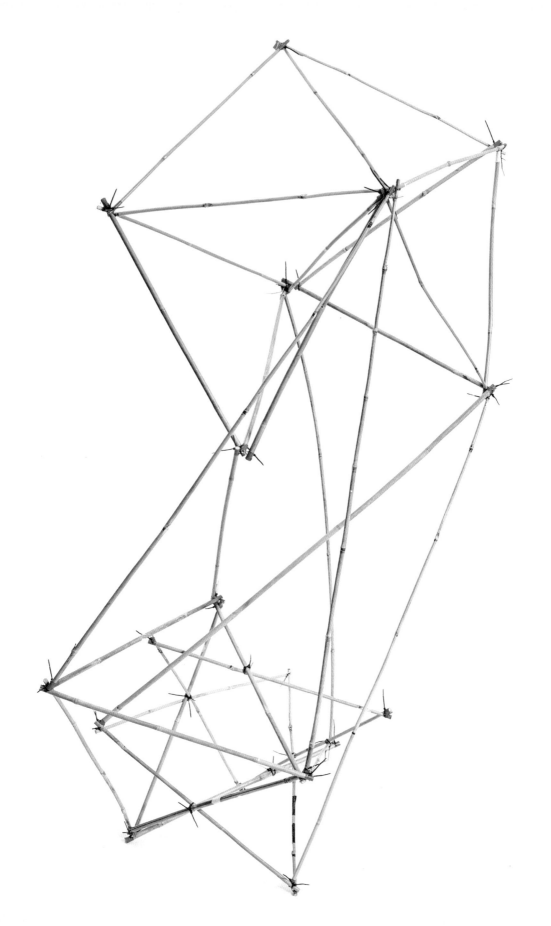

Context

Successful three-dimensional forms demand harmony in structure, utility and appearance – a problem identified as long ago as the first century BCE by Roman architect and engineer Vitruvius. Economy, through quantities of materials used and their arrangement, is also a central consideration. So is the sustainability of a project and, by implication, the sustainability of the planet. As author, polymath and architect of geodesic domes R. Buckminster Fuller argued: 'a designer is an emerging synthesis of artist, inventor, mechanic, objective economist and evolutionary strategist'.

Children develop an understanding of structure through accident and play, delighting in cycles of destruction and creation. However, adult life favours theoretical learning. Public, physical displays of fallibility are minimised. Risky and complex, structural exploration is left to experts and computers, to be calculated away from 'real life'. Yet all creative building requires experimentation and failure. Fuller also said: 'Most of my advances were by mistake.'

Surface

Wrapping structures with skins, membranes or walls separates inside from outside, protecting contents and inhabitants from heat, light, weather or theft. Surface can connect people on either side by transmitting sound, light or air. Holes enable glances, touch, fragrance – even people – to slip through. Marks can be organised into patterns to indicate use, ownership and to communicate meaning. Materials might be woven together sympathetically, they might collide or be invisibly blended; they can be used to promote or restrict movement.

Communities

Building is rarely entirely independent; as well as designers and architects, suppliers, fabricators and technicians are central to the process. Historically, communities came together to tackle big projects for the benefit of individuals and wider society. Barn raisings in the American West translated a community's

shared knowledge, skills and strength into buildings to store food. Building creates social as well as material structures. Jeweller Sarah Rhodes's work builds community through skill-sharing: her outcomes are physical necklaces, but also networks of makers.

This project invites you to develop unique structures and solve design problems as part of a team. Your organisational culture and structural form will depend equally on the members of your team and how they communicate with one another. You will gain confidence in exploring complex three-dimensional geometry at human or larger scale. This activity will help you develop structures quickly and creatively, and to consider scale in future projects.

118

Brief

In this project you will build a large-scale experimental structure using bamboo rods and cable ties. You will work with others to explore three-dimensional geometry and structure, designing through real-world testing of ideas and play. Repeated failure of test structures is expected. Enjoy your mistakes! Your design will emerge from this. Once built to your satisfaction, the structure(s) can be interpreted as prototypes to be inhabited, used or worn. You can think of them, for instance, as sculptures, installations, furniture, architecture or jewellery.

Materials needed

20 × 600mm bamboo canes
10 × 1,200mm bamboo canes

2.5mm drill bit, drill

50 cable ties, 2.5mm max width, any length

Coloured electrical tape (optional)

Note: The shorter bamboo canes (600mm) can be cut from the 1,200mm canes – so the kit can be made from 2 × 10 packs.

Preparation and joining instructions

First cut the bamboo to size, if necessary, using a fine-tooth saw, such as a hacksaw. Tape where you are cutting, to help prevent the bamboo from splitting. It is easier to saw with the bamboo secured to a flat surface.

When you have the lengths ready, you can wrap the ends of all the pieces in coloured electrical tape. This helps make the ends more visible, avoiding accidents later on.

Drill 2.5mm holes at each end of each bamboo length.

To join the bamboo canes, thread a cable tie tip through two or more ends, then feed it through the back of the cable tie head. Pull through to tighten. To release, simply cut with scissors or pull apart.

Step 1

Working with two to four other people, create two self-supporting structures. Use 20 (or fewer) short bamboo lengths and 20 (or fewer) cable ties.
Start by experimenting with joining and combining bamboos to make three-dimensional structures.
Do not overthink this task. You can refer to online resources about solids which are Platonic (all edges and faces are identical) and Archimedean (edges are identical, faces differ). Explore whether you want simplicity or complexity, stability or imbalance, strength or fragility.

Step 2

Once you have two structures, join them using cable ties. You can now incorporate up to 10 longer bamboos, if you wish, or any remaining shorter pieces. Explore different options before deciding on how you will do this and where the two structures will join. The new structure should be self-supporting.

Step 3

Look again at the new, combined structure:

- **Edit, by removing unnecessary bamboos.**

- **Clear internal spaces if you like.**

- **Add or move pieces to make the structure stronger.**

- **Make joins more elegant.**

Step 4

Now cover your structure with found or recycled materials that are easily available to you. Select your preferred material with care. Do you want it to be reflective, transparent or opaque? Consider where openings or entrances might go.

Step 5

Consider your structure at different scales: as architecture, installation, object or wearable.

Step 6

Photograph and draw your structure. Visualise it in use. How big is it? Where is it? Who is there? What are they doing? Climb inside. Model it. Try it different ways up. You may use collage techniques to add representations of people and location or backdrops.

Student work

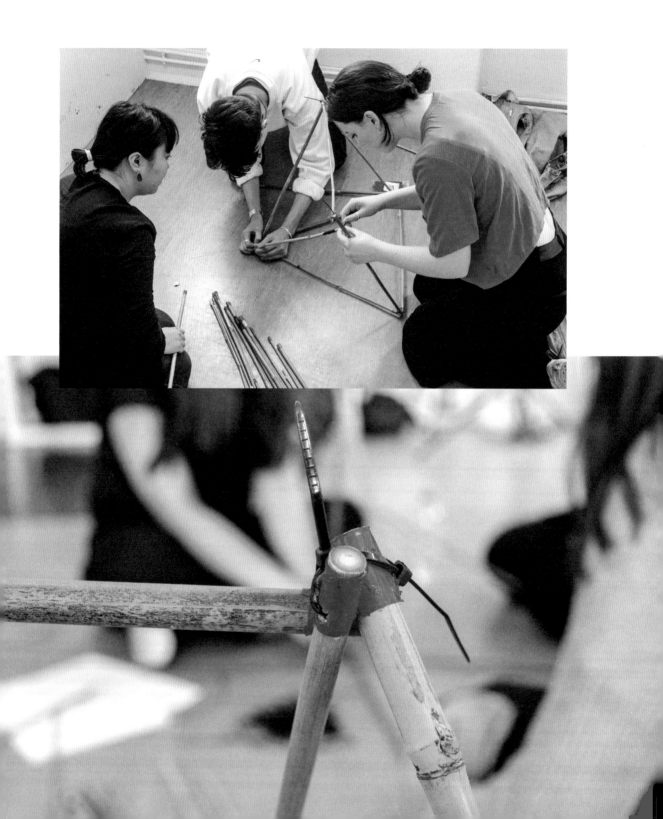

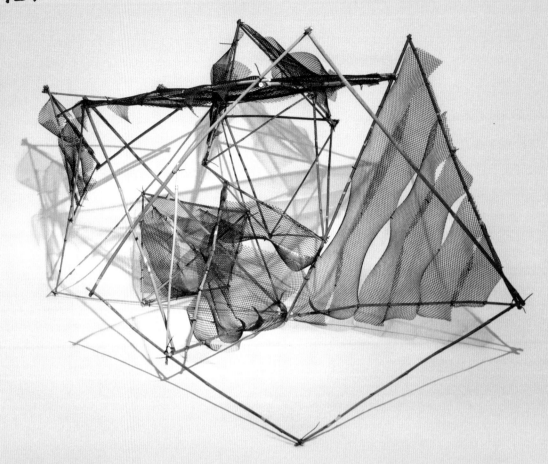

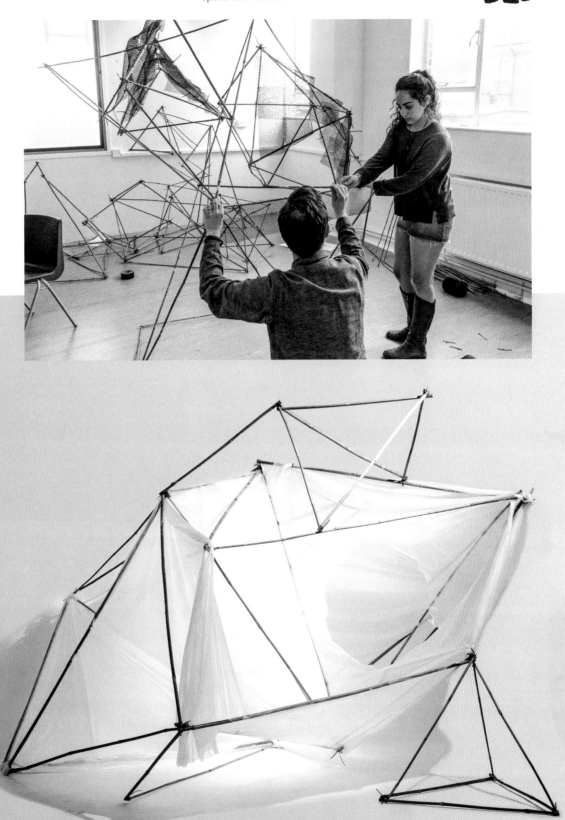

Language and Interaction

This project introduces the idea of public communication and engagement, which is most closely associated with communication design but also has significant relevance to areas of practice within fine art and applications within product design. The significant challenge of testing ideas in the real world demands clarity of concept, good communication skills and an effective strategy for initiating engagement.

The questions and answers below were the conceptual basis of the exhibition *Qu'est ce que le design?* (*What is Design?*) at the Musée des Arts Décoratifs, Palais du Louvre in 1969.

Madame L'Amic:

What are the boundaries of Design?

Charles Eames:

What are the boundaries of problems?

Madame L'Amic:

Is Design a method of general expression?

Charles Eames:

No. It is a method of action.

Madame L'Amic:

Can public action aid the advancement of Design?

Charles Eames:

The proper public action can advance most anything.

Context

This project invites you to engage with Charles Eames's assertion that design is a form of action.

As children we invent games as a way of initiating social interactions, but as we mature we become less playful and more inhibited in our interactions with one another. In addition, in today's world we are increasingly bombarded with information in our daily lives, further eroding the possibilities for reciprocal exchange. Design can reset this balance. As a 'method of action', it can initiate an imaginative interaction that is most sustained when the design is responsive to an audience's involvement. Rediscovering a spontaneous process of play will help you to develop strategies that might shift an audience from being passive viewers to active participants.

All interactive work requires a trigger that captures the interest of an audience and initiates their engagement. A trigger is something that stimulates curiosity enough to draw a stranger to look closer and might take the form of something that is out of place, beautiful or humorous. Think about the simple pleasure of a fortune cookie, the excitement of a tarot reading, the infectious energy of a flash mob or a line in a book that makes you laugh out loud.

In considering how you might approach this project, there are a number of artists, designers and studios that you could look to for inspiration. Random International's *Rain Room*, installed at the Barbican Centre, London, in 2012, was an extraordinary example of a responsive environment designed to be played with. Cameras detected human movement in the room, sending instructions for the rain drops to move away from visitors, who experienced the sight and sound of being in a rain shower without the associated sensation of getting wet. Tania Bruguera's 2008 performance work *Tatlin's Whisper #5* in which mounted horses came into the gallery space, corralling visitors in the way they would at a demonstration, is a pertinent example of how an experience out of context can have a profound effect on its audience. By using strategies employed by political authorities, Bruguera forces her audience to reflect on events that they might otherwise only read about in newspapers or view on television.

Design interactions are now increasingly created and played
out through digital technologies, with their capacity to perform
cognitive functions. Communication designers frequently
therefore regard their profession as being concerned with
the design of our interactions with the world rather than
with the creation of physical objects.

This project introduces this domain through an investigation
of the strategies that are needed to initiate audience interaction.
Your work will be deliberately 'lo-fi' and centred on
communicating playfully. Design is an iterative process that
starts by testing out ideas physically, so this exercise involves
a real space. Only when an idea has the proven potential
to create a narrative-rich environment should you consider
how digital technology might enhance your work.

Brief

Design and test a strategy for engaging and interacting with a public audience. Your only restrictions are that the concept must evolve from a given quote, and that the resulting interaction should enact the meaning that you apply to that quote in a memorable and surprising way.

Will you invite your audience to play? To touch? To complete a story? To taste? To perform?

To successfully complete this task, you will first design a trigger that grabs an audience's attention. You will then develop a situation that turns your audience members into active participants who walk away feeling challenged and enriched by the interaction.

There is no requirement to produce a design object, so you are encouraged to explore a performative or time-based approach. It is therefore important to consider an appropriate form of documentation that can capture a record of what transpires.

The quotes

'Life is a horizontal fall.' Jean Cocteau

'Words are not what make you see.' Patrick White

'I am a camera with its shutter open, quite passive, recording, not thinking.' Christopher Isherwood

'We have stood apart, studiously neutral.' Woodrow Wilson

'The limits of my language mean the limits of my world.' Ludwig Wittgenstein

'Examine for a moment an ordinary mind on an ordinary day.' Virginia Woolf

'Give me but one firm spot on which to stand, and I will move the earth.' Archimedes

Step 1

Choose a quote from the list on p.131 and start by deciding what it means to you, what it makes you think about and how you relate it to your own life and experiences. Ask friends and family to respond to the quote too, collecting their ideas and associations.

Identify the key words, ideas and metaphors used in the quote.

Step 2

Turn the ideas communicated by the quote and their associated meanings into a series of objects or images. What might a visual expression of your quote be?

Draw as many ideas as you can think of. For example:

Quote: 'Life is a horizontal fall.' (Jean Cocteau)
Interpretation: Life = light. Light can be represented by a candle which is also also metaphor of time.
Drawing: A candle burning sideways

Quote: 'Give me but one firm spot on which to stand, and I will move the earth.' (Archimedes)
Interpretation: A way to broadcast views
Drawing: Person standing on a platform at Speaker's Corner

Quote: 'We have stood apart, studiously neutral.' (Woodrow Wilson)
Interpretation: Things that go together but do not interact
Drawing: Surveillance camera

Step 3

How might you enact or perform the quote?
Experiment with ways you can physically communicate the quote as a simple gesture or action.

Examples

'We have stood apart, studiously neutral.' (Woodrow Wilson)

How might two bodies stand apart with studious neutrality?

What do you add to those bodies to communicate your ideas more clearly (for example, costumes, props or signs)?

'Life is a horizontal fall.' (Jean Cocteau)

How might a person fall horizontally?

How could you initiate an interaction between a person and a metaphor of their life? (See candle burning sideways example in Step 2.)

Step 4

Think about the last time you were confronted by a piece of design so seductive or provocative that you were encouraged to play with it. What was the mechanism that triggered that interaction?

Using examples of scenarios that have effectively engaged you, develop a strategy that you might use for engaging strangers with your quote.

General advice

Think of rituals used to mark different moments in life and how they always have specific symbolism or objects that initiate reflection.

A good strategy for making someone stop, look again and reflect on an idea is to give them something to hold, play with or take away.

Step 5

Choose a location in which to design your interaction. Consider the space's significance to the quote and whether passers-by will have time to interact. Visit your location and observe how people behave and move through the space. How might you reasonably interrupt their routines and established behaviours?

Be empathetic to your audience. What will they gain from the interaction? What does the quote give them or ask them to question? What game might they willingly play and for how long?

Step 6

Make a very basic version of your design and test it out on your friends. Does your idea make sense? Does it turn your viewer into an active participant? Does it sustain engagement? Is the essence of your quote communicated? What instructions are necessary to direct participants and clarify their role?

Example

'Life is a horizontal fall.'
(Jean Cocteau)

Begin with the religious connotations of lighting a candle (in memory, symbolic of a life offered up to Christ). Invite people to light and hold a candle sideways. What does it symbolise outside of that context? What does it mean for a variety of individuals of different ages, different cultural backgrounds and belief systems?

Step 7

Make props, matching the tone of your work to the choice of materials, their scale and construction. If your work is carefully crafted an audience is more likely to give the equivalent commitment and attention to engaging with it.

Consider the tastes of your audience. Use identifiable visual references and simple, portable materials.

Step 8

Safety first. Check the law before enacting your design.

Remain true to your idea while being prepared to adapt your approach to make the interaction successful. Persist even when your audience seems shy or wary.

Student work

'I'd rather be dead than cool.' Kurt Cobain

'The word "rather" became the starting point for our project. We quickly had the idea that we would let people decide on something – would they rather choose to be the same as everyone else, or to be different. We gave each participant a bag of salt and asked them to use it to draw a path. We were really interested in whether people would decide to follow a "path" created by others or if they would prefer to go their own way.'

Julia Luckmann and Tallulah Jones

'Give me but one firm spot on which to stand, and I will move the earth.' Archimedes

'This intervention was staged in Trafalgar Square, London. Participants ranged from children to the elderly and included people from all over the world. All were asked to consider the question "how would you change the world?"'

Pine Chirathivat

'There is no female Mozart because there is no female Jack the Ripper.' Camille Paglia

'We wanted to use our project to challenge this statement. We painted portraits without faces of Mozart and Jack the Ripper and invited people who didn't agree with this quote to put their face to these portraits.'

Vector Huang and Nanlin Shi

Chapter

8

Position

Artists and designers are experts at reinvention, constantly shifting position to allow for investigation and discovery. This requires a certain fearlessness as well as a degree of self-awareness and control during the process of situating your practice.

Talk to any artist or designer and their career trajectory will almost always have involved regular change, evolution and diversion. Some of these shifts will have been responses to opportunity, some driven by necessity – often financial – and some will have been initiated by the ever-changing nature of the creative industries, their markets and technologies. Positioning yourself is therefore an ongoing process of sustaining your creative practice within a field that is in constant flux.

The role of an art school is often to question, expand and destabilise definitions of practice. It does this by pushing back at conventional distinctions of subject in order to open up the potential for working within an expanded field of art and design. For anyone at the beginning of this journey, it can be exciting and confusing in equal measure. The Foundation course offers practical ways of navigating the process of defining your own creative identity.

We use the term 'diagnosis' to describe the process whereby you identify which areas of art or design practice you could successfully situate yourself within. The projects that you have completed so far have tested your ability to adapt to a range of themes and modes of working. You can now use these experiences and the work you have produced to help with diagnosis. You will do this by identifying and interpreting the decisions you made in response to the different projects.

Rather than allowing the aesthetic or technical aspects of your work to be the deciding factor in thinking about your future trajectory, take into account the motivations for your work and how that work functions in the world. You will need to put aside preconceptions about what you think you would like to become and instead consider how your behaviours, approaches and sensibilities lead you towards certain fields of creative practice.

Situating your practice is not an exact science, nor is it something that is set in stone. The intention of this process is to identify possible routes into further study and towards specialisation and not to restrict the span or identity of your future practice. The following set of questions stemming from each of the diagnostic projects is simply a provocative tool to encourage you to take a position and begin to consider the question: where do I fit?

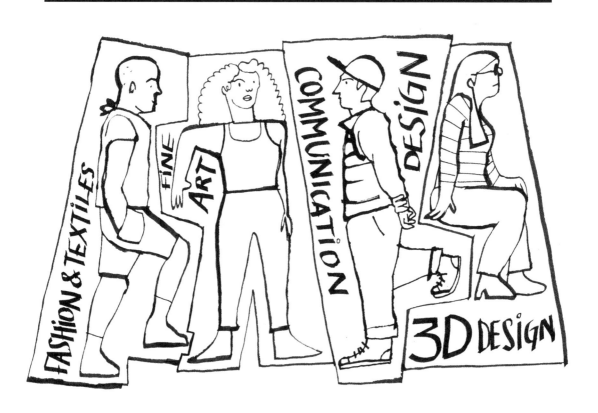

Image and Narrative

- Did the structured way of working required by this project support your creativity or was its impact on you negative?

- Were you able to adapt your ideas and select a visual language that worked effectively with the screen-print process?

- Did your craft skills bring the necessary sophistication and precision to the task?

Body and Form

- Did drawing lead your design process, giving you solutions for form, proportion, fit and silhouette?

- How effectively did your two-dimensional designs translate into three-dimensional designs for the body?

- Did your work transform the silhouette of the body?

Surface and Meaning

- Was it fruitful using your own experience, imagination and perception of the world as a starting point for making work?

- How did you contextualise your work conceptually, philosophically and in relation to its intended audience?

- Did your enquiry open up the potential for an ongoing exploration?

Space and Function

- How did you respond to decisions about scale? Were you drawn to working big, small or somewhere in between?

- When exploring different applications for your forms, what potential use most captured your imagination and seemed to suggest the greatest possibility for you?

- How did you respond to working with others?

Language and Interaction

- Did the open-ended nature of this brief prove challenging and stimulating or did you feel less able to use your skills when asked to work in this way?

- To what extent did your outcome effectively engage with its public context?

- Was the idea contained within the quote communicated directly and with clarity or was the provocation more ambiguous or subjective?

Art or design

It is necessary from the outset to introduce a degree of sophistication to distinctions between art and design, particularly because the lines between the two can often blur.

Artists and designers have a largely shared skill set and knowledge base but the work they create, however indistinguishable in terms of technique, subject matter and visual language, is made for entirely different reasons. Attempts to define or make clear distinctions between art and design are always contestable, but at the beginning of a diagnostic process it is useful to identify a simple delineation between the two:

Art

An artist's practice generally emerges from their own individual concerns explored over varying durations in the studio. The work is then usually presented to a knowing public either in galleries or in designated public spaces.

Design

Design is largely initiated externally from the needs or desires of a client or external body. The functionality of the designed solution is as important as its desirability, craft and aesthetics. Design is in the public domain and, as such, its messages, meanings and functions are inextricably linked to the political, social and economic concerns of its audience/user and its context.

Exercise:
Artist or designer?

Below are a series of dichotomies that, broadly speaking, relate to being either a designer (in red) or an artist (in yellow). We are not suggesting that the statements are mutually exclusive – there are artists and designers who will be working in ways that challenge and confound these stereotypes. However, by plotting yourself on the line between the two, you can begin to gain clues about where your tendencies and identity might lie.

- Work with or within the system

- Work to a client brief

- Work fast to deadline

- User

- Function

- Question, disrupt or undermine the system

- Initiate work from within yourself

- Work at a self-determined pace

- Audience

- Non-function

Exercise: Ways of working

This exercise will help you begin to explore your personality as a practitioner. These oppositions do not relate directly to areas of practice, but rather suggest context, methodologies and ways of working. Again, plot yourself on the line between each dichotomy.

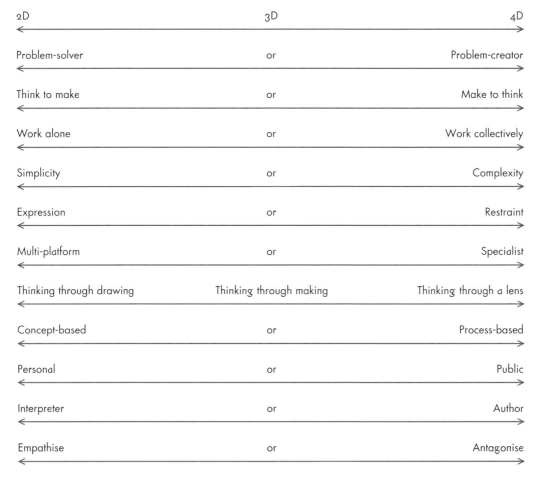

2D	3D	4D
Problem-solver	or	Problem-creator
Think to make	or	Make to think
Work alone	or	Work collectively
Simplicity	or	Complexity
Expression	or	Restraint
Multi-platform	or	Specialist
Thinking through drawing	Thinking through making	Thinking through a lens
Concept-based	or	Process-based
Personal	or	Public
Interpreter	or	Author
Empathise	or	Antagonise

Take some time to reflect on your responses to the questions and the exercises in this chapter. Following this, read through the projects in the next chapter, 'Specialise'. Each project there relates to a particular area of art or design and it may be that at this stage you are able to identify which of the four projects it will be fruitful for you to undertake. Write a short rationale (a maximum of 500 words) describing where you see your practice going next.

Interview
Birgit Toke Tauka Frietman, designer and artist

Dutch designer and artist Birgit Toke Tauka Frietman gravitated towards jewellery design while on her Foundation course at Central Saint Martins. After gaining specialist embroidery skills working for fashion designer Iris van Herpen, she undertook a degree in jewellery design inspired by 'the enormous freedom in material and technique that the discipline offered'.

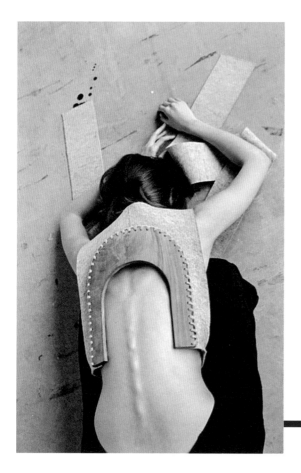

Throughout my degree studies, I was focused on exploring the close connection jewellery has to the wearer's skin and to his or her story. I think it is this core interest that allows me to translate my practice into other disciplines. The benefit of this approach is that it does not restrict me to specific materials or to working at a particular scale. I can approach briefs quite freely and respond in a very open way.

This hybrid approach and interest in collaboration allows Frietman to undertake regular work for fashion designer Grace Wales Bonner alongside commissions for the likes of Swarovski and Tim Yip while also making sculptural work for gallery display.

The aim within my art and design practice is to represent the intimacy that we can have or create with an object, a person, an other than ourself. With my educational and professional background in jewellery, sculpture and embroidery, my work ranges from intimate body pieces to large rotating mobiles, often combining wood and textiles as the main materials.

Collaboration is incredibly important to me. I have come to understand that working together with other artists and designers enriches my practice and results in more profound work.

Instagram: @bttauka

Interview
Mark Laban, furniture designer

Mark Laban is a furniture designer whose particular interest lies in exploring how traditional crafts, cultures and skills can be interpreted through contemporary digital manufacturing.

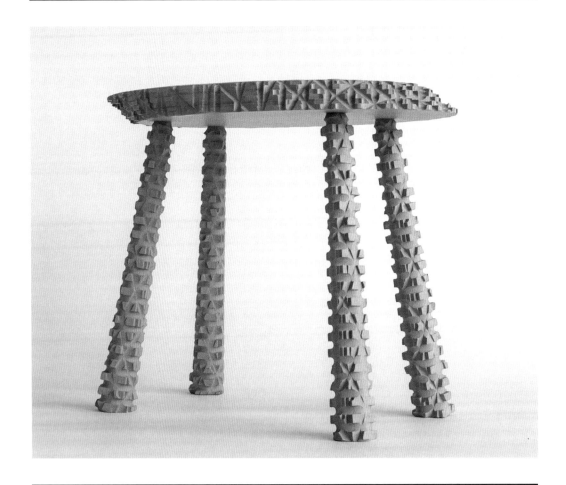

Laban's journey towards his current practice was not a straightforward trajectory:

I stepped tentatively into the world of art and design via a Foundation course and then a Fine Art degree at Central Saint Martins. Beyond an educational context, however, I struggled with art as a vocation. I came to see the total freedom and lack of real-world parameters, which had at first attracted me, as obstacles to making work.

I soon realised that some of the important critical thinking skills I had learned through studying art could be readily transferred to the process of design, and in this field I could satisfy my impulse to develop objects that have both practical function and conceptual authenticity.

The majority of his work to date has taken the form of one-off bespoke commissions for private clients.

Through these commissions I've been able to build on the design language that I've developed through experimentation with a three-axis CNC milling machine. The use of digital manufacturing technology as a tool in my practice actually grew out of an underlying fascination I had with traditional craft skills and techniques. I began to question how these two approaches which on the surface seemed so fundamentally opposite could be synthesised in meaningful ways.

In 2018–19 Laban undertook a research project at Kyoto Institute of Technology's Design Lab:

It is a facility that acts as an incubator for collaborative design-led, people-centred research and innovation. Working in Kyoto, with its precious cultural heritage and its network of traditional makers, is an ideal place for me to further explore the intersection of tradition and innovation through design.

Instagram: @_mark_laban

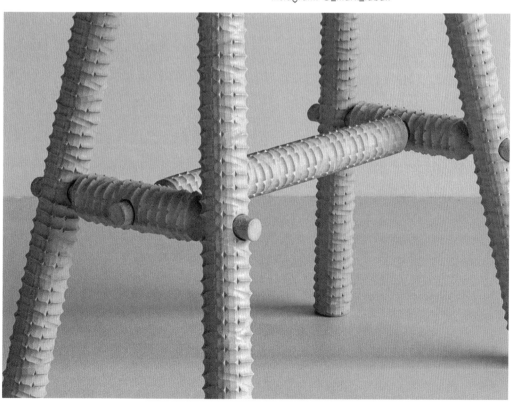

Interview
Rahemur Rahman, fashion designer

Rahemur Rahman uses fashion design to address issues of identity and sustainability. As part of the Central Saint Martins Insights programme, Rahman identified fashion design (menswear) as the ideal discipline through which he could explore his identity and cultural heritage.

The narrative that underpins my work is quite transparently my own experience as a British Bangladeshi. I think it's important we all find a way to tell the story of our life lessons and experiences. I get the confidence to speak about my dual heritage from my mother and father, who have been fortunate enough throughout their lives to be able to express their cultural identity unapologetically.

If you are authentic and stay true to who you are, the time will come when people need to hear your story. I have been working in fashion for over four years and it is only now that people are ready and willing to hear and see visually through fashion what it means to be 'Made in Bangladesh'.

Rahman collaborates with artisans and producers in Bangladesh to produce his work.

I work with them to design and make textiles that I turn into menswear for the fashion conscious consumer. Right now, my work is guided by how clearly I can retell the story of being 'Made in Bangladesh'. This term is deeper than the textiles and fashion that I design, it also discusses the identities we create and function within.

Instagram: @rahemurrahman

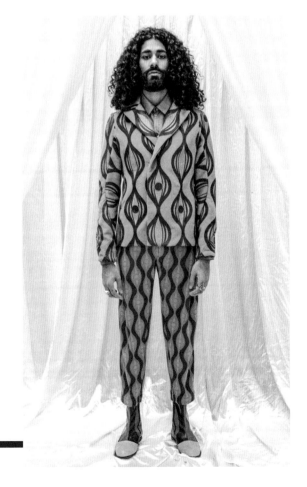

Interview
Rose Pilkington, digital artist

Rose Pilkington is a London-based digital artist and motion designer. After specialising in photography during her Foundation course at Central Saint Martins, she progressed onto a degree in Graphic Communication Design and then refined her software skills during internships.

Pilkington's freelance success stems from her distinctive visual language, which she identified while writing her dissertation.

I wrote my dissertation on the subject of colour, and how its presence within our surroundings can have a profound effect on us psychologically. I carry with me all of those ideas and themes and they continue to inform my work even now.

For Pilkington, the experimentation that was so integral to her experience as a design student is still central to her creative process.

The need to keep experimenting and, in turn, learn new techniques informs the way I create imagery. The still and moving imagery I create is entirely CGI, essentially using technology to facilitate visual expression.

Now that my practice is established, I am excited to begin working towards breaking away from a purely digital space, finding ways of bringing the imagery I create into a physical space, or into tangible objects or sculptures. I rarely get to see my work on a large scale, and especially when colour is such an important factor in my work, I feel it is something that needs to be seen and felt in immersive spaces or environments.

Instagram: @rosepilky

Chapter

9

Specialise

During this stage of the Foundation course at Central Saint Martins, students typically complete between three and five projects over a ten-week period, with project durations varying from one week to three weeks. These projects are designed to continue the diagnostic process but within a more defined area of practice. Throughout this stage, students build their knowledge, understanding and experience in an area of specialism and focus on the acquisition of skills relevant to that area.

During the Specialist Projects stage, the emphasis is placed on beginning to identify and develop each student's particular abilities, concerns and unique visual language. It is during this stage of the course that students assemble a portfolio of work for progression on to specialist degree courses.

We have selected four projects from this stage of the course that cover four main subject specialisms: fine art, communication design, fashion and textile design, and three-dimensional design. While you may not wish to complete all of these projects, there are key processes and skills illustrated in each project that are transferable and of great value to all disciplines.

Communication Design

Project Title: Made to Persuade

The art of persuasion is a fundamental aspect of all the Communication Design disciplines. Harnessing the authority of a graphic design language with provocative ideas and messages is at the heart of this project. The use of design to bring about societal change is also an important area of practice that this project introduces.

Context

Communication design is a democratic discipline; it is for everyone. The language of communication design has an authority and a prominence that can be used to transmit powerful messages. Think of Shepard Fairey's 2008 *Hope* poster, which featured a stylised image of then US presidential candidate Barack Obama. It became an iconic symbol of Obama's election campaign, transmitting a clear message to the people of America about the possibility of positive change to the status quo.

From the Soviet propaganda posters of the 1920s to the media-heavy political campaigns of the present day, communication design has a long history with political discourse. However, design activism is a relatively recently defined area. It asserts the potential for the designer to be associated with originating a message, rather than simply communicating one. As a communication designer you have the opportunity not only to reach a large audience, but also to create a platform to speak out about issues that are important to you.

Ken Garland's *First Things First* manifesto written in 1964 was a backlash against the world of advertising and what he and his contemporaries identified as the 'high pitched scream of consumer selling'. They proposed 'a reversal of priorities in favour of the more useful and more lasting forms of communication'. More recently Dutch design studio Metahaven has moved away from a straightforward graphic design practice towards one that engages with political and societal enquiry and critique.

This project asks you to engage an audience with an issue by eliciting their participation in your work. How can you change the way people think about something through an experience that you give them?

Another aspect of this project involves a consideration of the semiotics of objects; it will look at how we can take one thing with its own meaning, place it in another context and use it to communicate a very different message. This practice is well established in both art and design. A 2017 Tiger Beer campaign by advertising agency Marcel Sydney spoke out

about the impact of air pollution by developing 'Air-Ink' –
a range of pens, markers and sprays containing ink made
from vehicle-exhaust soot. By taking a harmful byproduct of
modern life and transforming it into something associated with
creativity and positivity, the campaign forced a confrontation
with the issue of pollution. Crucially too it was playful and
engaging – a powerful approach to drawing in an audience
and one that you might employ for this project.

Design, when used effectively, has incredible authority and
influence; however, graphic designer Milton Glaser is critical
of 'pieces that satisfy their maker and express their rage, but
do not transform other people's visions'. The aim of this project
is therefore to discover a range of strategies for using graphic
design language to create impact in the world.

Brief

This project asks you to harness and exploit the power of communication design to activate an audience. You will apply design thinking to addressing and offering solutions for wider social and political problems. We want you to design and make something that provides a new way of thinking about or interacting with the world. You will reference or adapt an existing object to explore how, through a process of repurposing, you can encourage alternative views on the world.

To successfully complete this brief, keep in mind that this project does not ask you to simply raise awareness about an issue. It requires you to use your emerging design thinking and skills to call people to action, and to call upon your audience to help you make the world a better place.

Step 1
Identify your subject/issue

Begin by asking yourself the following question: what has annoyed me or made me angry today? Think about things that affect you in your everyday life – it could be as small as that piece of chewing gum you stepped on after someone spat it out onto the street. Aim to identify at least five possible starting points.

Step 2
Research

How do the issues you have identified relate to the wider world? Do they affect most people or only some? Answering these questions will help you to identify your target audience: whose behaviour, opinions and thought processes do you want to change?

Use a variety of approaches to carry out research into your issues: conduct interviews and observations, access news archives, or use the library to identify a historical context.

Step 3
Select an idea

Select one subject or issue that you would like to take forward. Bear in mind humour, contemporary relevance, as well as broad appeal and recognition.

Step 4
Clarification

Ask yourself what change or shift you want your work to achieve that will address the original anger or annoyance you identified at the start of the project.

Step 5
Identify and source an object to repurpose

Look at what the issue is, and then identify an object or thing that has a relationship with it. Embrace the obvious during this process. For example, if your issue is to do with time management you might choose to work with a clock.

Step 6
Explore the process of repurposing

How can you adjust this object so that the way it is used or experienced changes, effecting a shift in thinking or behaviour? Consider some or all of the following:

- **Creating packaging that transmits a new message about the object it contains.**

- **Adding or removing something to create a shift in meaning.**

- **Changing the context – what happens when you take something away from the place where you expect to find it and move it to a different location?**

Step 7
Design and visualise

A successful outcome for this project will usually involve working with the visual language of the existing object and subtly reconfiguring it so that it transmits a different message.

Use your sketchbook to record and develop the ideas you have for repurposing. You can use a combination of photographs of the object you intend to repurpose and your own drawings and annotations. Use your visualisations to plan and prepare for the making process, taking into consideration what process you will use to adapt your object (digital manipulation, physical removals/additions, changing context). Think about what materials you will need to make those adaptations.

Step 8
Make

Having identified a process and gathered the materials most appropriate to the communication of your message, make your work.

Step 9
Test

Now it is time to test your work, to take it to an audience and see how they respond. Look for their initial reaction (shock, surprise, laughter?). Is it what you anticipated? Ask your audience to describe what the work makes them think about. Does it make them think in a new way or consider behaving differently?

Student work

More Please

Popcorn packaging to encourage you
to watch more films with female leads.

Diandra Elmira

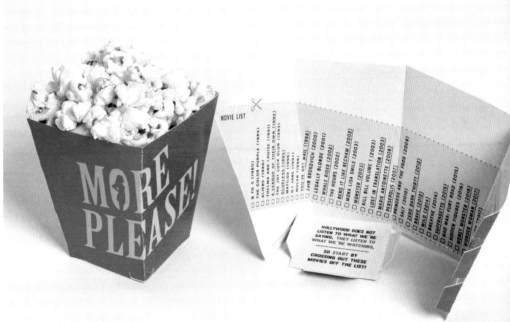

Buckingham Palace Air

A bottle of royal air, questioning
the currency of the monarchy.

Sandra Leung

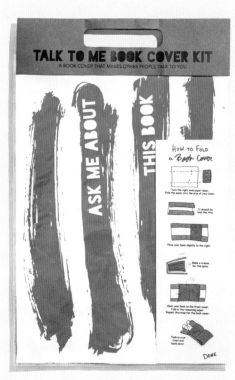

Talk To Me

A book cover encouraging
communication with strangers.

Maya Kubota

Anti-Surveillance Device

Designed to provoke discussion around surveillance.

Gabriella Rutzler

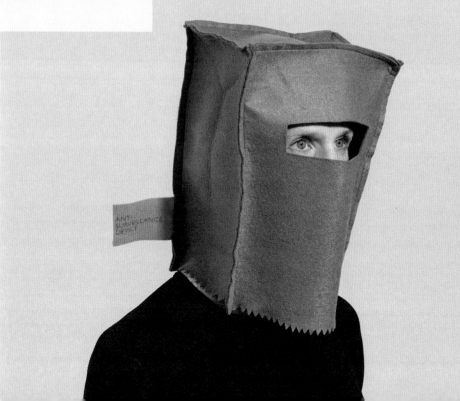

A Woman's Everyday Weapon

A provocation suggesting the use of a newspaper to stay safe.

Freya Buckley

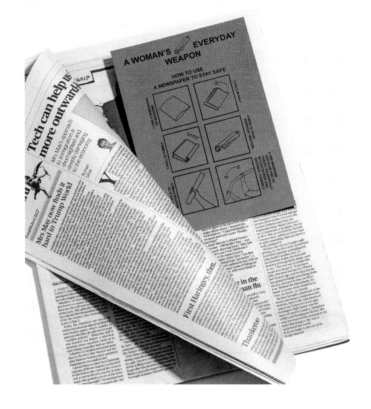

Made of Money

An origami kit questioning the value of things.

Orin Bristow

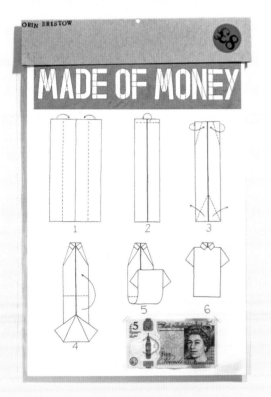

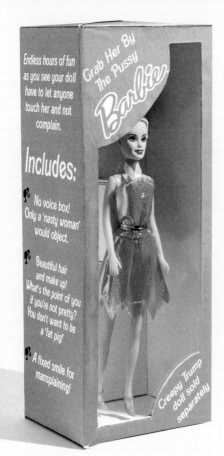

Trump Doll

Includes:
• No voice box!
• Beautiful hair and make-up.
• A fixed smile for mansplaining.
Don't let the next generation of women think that this is their only role. All proceeds go towards the charity UK Feminista, which teaches young girls about gender equality.

Fleur Wilson

Presidential Kit

All you need to run a successful presidential campaign.

Fiorenza Deandra

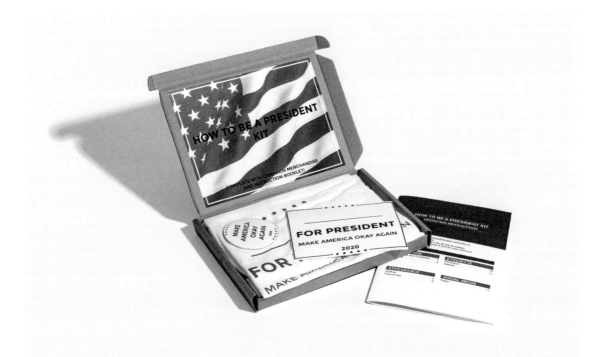

Exercise: 30 ideas in 30 minutes

This is an ideas generation exercise that you can use to get any project started. In setting yourself a deadline of originating and visualising one idea per minute for 30 minutes, you generate a pool of ideas (some good, some mediocre and some awful!) that you can then edit, refine and develop into a number of potential solutions.

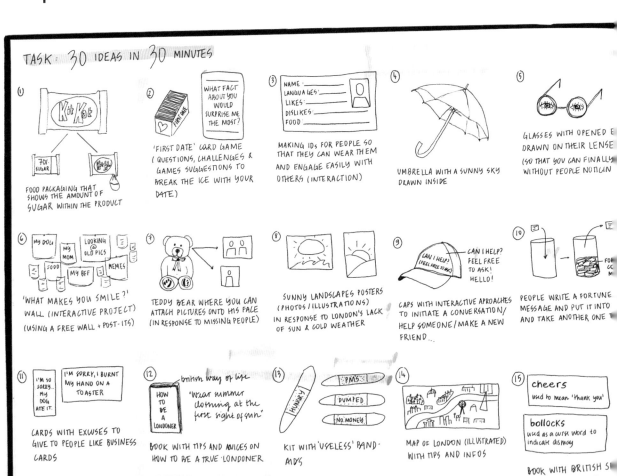

Maria Ferro

MAKE YOUR OWN BOYFRIEND
KIT (DOLL)
→ PAPER?
 → FASHION PAPER DOLLS

(17) WELCOME TO LONDON KIT
· VITAMIN D CAPSULES
· LITTLE GUIDE
· RAINCOAT
· MAP
· BOOK WITH BRITISH EXP. (15)

(18) ANTI STRESS KIT
· STRESS BALL
· CHOCOLATE BAR
'PUNCH HERE' POSTER

(19) TRAVEL KIT
· PASSPORT
· ORIGAMI PLANE TO MAKE
· WORLD MAP TO MARK LOCATION
· FLIGHT TICKET TO COMPLETE

(20) BOOK TO SELF-KNOWLEDGE
WITH EXERCISES SO THAT
YOU'LL KNOW YOURSELF
BETTER

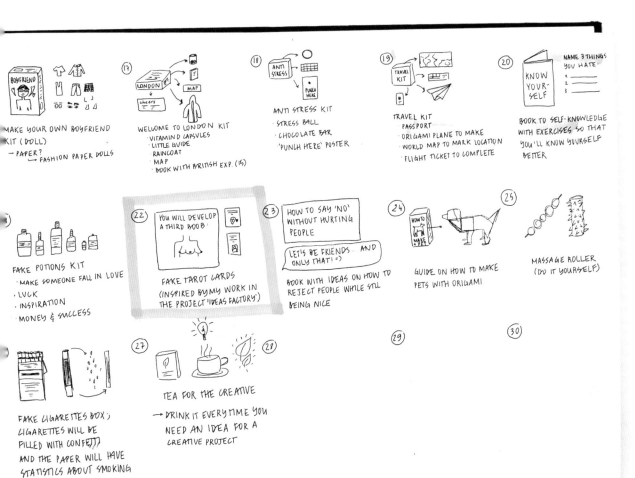

FAKE POTIONS KIT
· MAKE SOMEONE FALL IN LOVE
· LUCK
· INSPIRATION
· MONEY & SUCCESS

(22) FAKE TAROT CARDS
(INSPIRED BY MY WORK IN
THE PROJECT 'IDEAS FACTORY')

(23) BOOK WITH IDEAS ON HOW TO
REJECT PEOPLE WHILE STILL
BEING NICE

(24) GUIDE ON HOW TO MAKE
PETS WITH ORIGAMI

(25) MASSAGE ROLLER
(DO IT YOURSELF)

FAKE CIGARETTES BOX;
CIGARETTES WILL BE
FILLED WITH CONFETTI)
AND THE PAPER WILL HAVE
STATISTICS ABOUT SMOKING

(27) TEA FOR THE CREATIVE
→ DRINK IT EVERY TIME YOU
NEED AN IDEA FOR A
CREATIVE PROJECT

(28)

(29)

(30)

How to subvert a design language

The subversion of existing and widely recognised objects and design languages is a powerful tool for playing with the expectations of viewers and delivering alternative messages. A designer can wilfully deceive their audience by creating a conflict of signals between the aesthetic of an object and its textual content.

 Success in this practice requires a sophisticated understanding of the ways in which material, form, colour, finish and typeface communicate.

Reference

Carefully select your reference. It helps to choose something that is widely recognised. Crucially, your reference must connect conceptually with what you are trying to communicate. In the example here, a box of pills is used to covertly deliver a secondary and conflicting message through text and image, which is a comment on the possibility of a panacea for the United Kingdom in Europe.

Aesthetic and finish

A close observation of the design conventions of the object you are referencing is essential – this is not a vehicle for your personal aesthetic preferences. You will need to reproduce every visual and tactile detail as exactly as possible in order to create the initial deception. Even subtle differences in colour, feel, scale, form and typographic styling could undermine the delivery of your subversive message.

Voice

Copywriting will be key. You will need to pay close attention
to the language of your reference point. In this case the
student has adopted the authoritative and neutral tone
of the pill packet, a language we inherently trust, using
it to make a political provocation.

Scene Peng

Fashion and Textiles

Project Title: Material Restriction

Co-authors: Oonagh O'Hagan and Christopher Kelly

This project enacts the skill set of a fashion designer, taking you through a complete design process from concept to garment. It continues the diagnostic process by integrating an extensive range of fashion and textile design skills within one exercise. Starting with the deconstruction of a fabric, in this case corduroy, this project goes on to explore textile design, experimental draping, design drawing and collage.

Context

'Fabric is everything. Often I tell my pattern makers, "Just listen to the material. What is it going to say? Just wait. Probably the material will tell you something."'
Yohji Yamamoto, quoted in *Baude*, November 1997

Fashion and textile design are distinct yet interwoven disciplines. Fashion design is concerned with the aesthetics of the body and its relationship with culture and society through clothing, whereas textile design focuses more specifically on the design and construction of fabric through print, knit or weave.

Our approach is to encourage the fashion designer to embed textile construction within their working process, and for the textile designer to consider the body, where relevant, as they develop their work. An example of the potential of this cross-disciplinary approach can be seen in the work of Yohji Yamamoto. His design language reflects his fascination with textiles and the potential of traditional Japanese techniques for textile construction, embroidery, knit and dying.

In the fashion and textiles industry, restrictions such as budgets and time are a constant. However, using restriction as a method of creating innovative and original approaches to problem-solving is also a crucial aspect of the design process. Here the restriction is a material. Along with having clear practical and tangible functions in fashion and textiles, materials can also have symbolic or abstract functions such as the ability to evoke mood, memory or meaning. In this project, you are asked to research the material corduroy.

Corduroy has been chosen for two reasons: its connotations and its construction. Firstly, historically it has connoted luxury – it was popular with the aristocracy in both England and France during the eighteenth century – and by contrast it has also been associated with workwear due to its durability. Secondly, its unusual tufted construction and practical properties means that it is a material that has been used in both fashion and interiors.

Historical, cultural and personal references can provide fashion designers with key areas of inspiration. Designer Craig Green is a master at successfully inverting cultural references

and reinventing them in his own vision. These references can be seen practically in his garment fastenings, their function and fabrication, and more abstractly in his recurring theme of 'uniform' which he says relates to his childhood experiences of, and fascination with, communal dress.

This project introduces the two key skills that underpin fashion design: drawing and draping. Drawing is the basis of a fashion designer's education and the tool with which they develop and communicate their language. It is also a method of learning and understanding the structure and movement of the body. Drawing also remains a primary communication tool in an industry where designs are interpreted and constructed by multiple skilled hands.

Designs cannot be realised through a two-dimensional design process alone. Whether it is creating 'structures' for the body or the analysis of the composition of a material, using construction and three dimensions can help evolve initial ideas. This experimental approach leads on to the more formal technique of draping. Along with a physical interaction and understanding of materials, draping gives a 360-degree view of the process and the emerging design.

Brief

Through extensive research and drawing you will take inspiration from the material corduroy, exploring and deconstructing its structural properties and aesthetic as well as responding to its historical uses and cultural associations. You will use this research to inform a series of textile samples that become the basis of a fashion design process. You will then work three-dimensionally on the body, using draping to generate design ideas that are articulated through further drawing. At the conclusion of your project, you will create a garment that merges your research, samples and draped forms with your own ideas and concerns.

Step 1
Fabric research

Look into corduroy's origins, applications and cultural associations. Create a body of photocopied visual references. These should be a diverse mix of non-fashion related images.

Step 2
Drawing samples

Now develop your visual response to the fabric corduroy using drawing and abstract mark-making to explore its pattern, structure and texture.

Create a series of 10 drawn samples on different types of paper using a range of media.

Step 3
Collage

Cut up your fabric research photocopies and combine them through collage to begin to create design ideas in your sketchbook.

Now integrate your drawing samples with your photocopied research to combine historical references with pattern, texture and colour. Focus on bringing together interesting textures, colours and shapes identified through your research. You will later be developing and abstracting these shapes and forms to create your final designs.

Step 4
Textile samples

(See p. 180–1.)

Create a series of five textile samples that explore some of the ideas suggested by your collages.

Begin by collecting a range of traditional and non-traditional materials that suggest the texture or mood of your original collages. This is an experimental process so feel free to integrate any found materials that have particular tactile or aesthetic properties of interest.

These fabric/material samples may include elements of sewing, knitting, weaving or any joining techniques that relate to your initial research. Each textile sample will be used to inspire shape, colour and texture for your garment or textile design.

Step 5
Working on the body

To initiate the design process, photocopy your textile samples and begin to place the photocopies on the body. This process should be repeated several times, placing the shapes in varied combinations on the body. You can also use the photocopier to explore different scales.

These design ideas will inspire the mood, colour and texture combinations that will be translated through the draping process.

Step 6
Drape on the body

(See How to drape, p. 173.)

Initiate an abstract way of constructing shapes, combining fabrics and integrating materials on the body through a draping process. This is an iterative process that can help you identify a range of possible silhouettes and design ideas.

Step 7
Document the process

As you progress through the stages of the project, continually take photographs and create observational drawings. Documenting your work in this way will help you to reflect upon, rationalise and evaluate your development and design process. It can also provide you with new material to photocopy and work into further collages and design drawings.

Step 8

Focus your design language

Analyse your research, samples, collages and draping to identify a key colour, shape/structure and texture on which to base your final design. Explore different combinations of these three aspects when finalising your design.

Consider why you have chosen to focus on these aspects. How might they inform the function and context of the garment?

Step 9

Select a key material

Select a key material to work with by:

- **Visiting a traditional material source such as fabric shops, but also non-traditional sources such as hardware stores.**
- **Making or customising a material.**
- **Using a deconstructed existing garment.**

The structural and tactile properties of your research and experimentations should directly inform the materials you select.

You might now also consider the finishes of your garment by collecting construction items such as pockets and fastenings.

Step 10

Construct your garment

There are three approaches you can use to directly translate your drawings and samples onto the body and realise your final garment:

- **Drape and pin your fabric directly onto the body to construct the shape and structure of your garment.**
- **Construct shapes on the body. For instance, with paper (as per the Body and Form project on p. 99) that you then use as a pattern and cut from your chosen fabric.**
- **Assemble your garment from deconstructed clothing. Then take each element apart to transform a pattern that you cut from your chosen fabric. For example, if you need a sleeve, simply cut a sleeve from an old shirt or jacket and take it apart to create a pattern. You can also incorporate elements of existing clothing directly into your finished garment.**

Don't be limited by your technical abilities or by conventional methods of construction. Allow your design to come to life by any means possible as an exploration of an approach rather than a conventionally finished garment.

Step 11

Illustrate your design

Capture your final piece through drawing.

By using a combination of drawing techniques, you can dynamically describe the overall feel and aesthetic of the design. The illustration can be a useful tool to communicate the mood of a garment even if it isn't fully resolved.

How to drape, with Christopher Kelly

You will work with a partner, using your own selection of pipes, poles, tubes and rope to create an abstract form that relates to the body. The size, weight and appearance of the materials you source directly inform what you create (for example, natural branches, plastic tubing or different thicknesses of wooden dowel).

When a stable structure has been established, you will drape existing garments and a length of fabric over, under and inside the form you have created. This process will be used to initiate the two-dimensional design development process.

1

Begin by connecting your selection of pipes, poles or tubes to form a structure that will work with the body.

Work instinctively and in response to your model's body.

Construct forms that will work in conjunction with the body to create an original silhouette.

2

Using rope, yarn or tape, attach the form to your model so that they become integral to one another.

3

Introduce existing garments to the form and body. Place the garments across both elements as if they are one.

4

Now introduce fabric, using tying, knotting, twisting and interlinking to connect the garments, fabric, form and body.

5

Consider the balance of all elements, trying various combinations and placements of fabric and form.

6

Document (photograph and draw) the final silhouette from all angles. This documentation will form the basis of a continued design development.

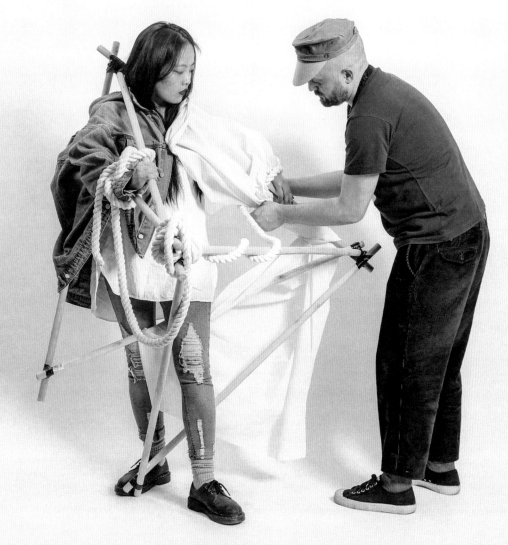

How to collage the figure, with John Booth

The following guides to collaging the figure outline three potential approaches to generating quick imagery in your sketchbook. The aim of these collages is to explore form, pattern and colour as part of a design process.

Technique 1

1

Through observation, tear and cut out the basic forms of the body and garment in newsprint. Stick the newsprint forms onto a sheet of A3 cartridge paper using a mixture of masking tape and glue stick.

2

Add blocks of pattern and colour in ink, gouache and marker pen referencing texture, weave and pattern from your textile research.

3

Using marker pen and wax crayon, add the main details of the garment, paying attention to its structure and where it connects with the body. Finish by adding the face, feet and line of the legs and arms.

Technique 2

1

Use marker pen, graphite stick and ink to create
a series of quick drawings of pure pattern and
texture based on your textile research.

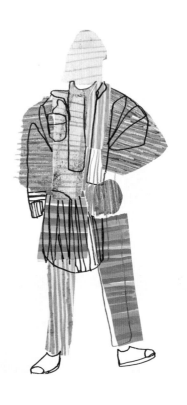

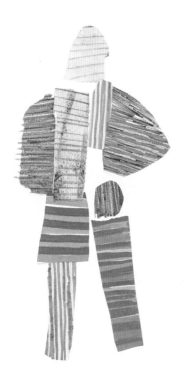

2

Through observation, tear and cut these
drawings into shapes and assemble them
into the silhouette of the figure and garment.
Stick them in place onto a sheet of A3
cartridge paper using a glue stick.

3

Add the outline of the garment and figure
in marker pen using a continuous line.

4

Using pen and crayon, add detail
to the garment, figure, face and feet.

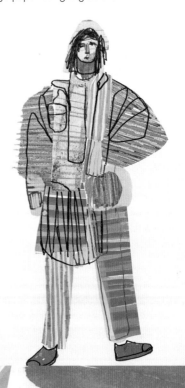

Technique 3

1

Gather and photocopy corduroy samples.

2

Draw the outline of the figure and garment in two thicknesses of marker pen using a continuous line.

4

Add blocks of colour and further texture with gouache and graphite stick and details in marker pen.

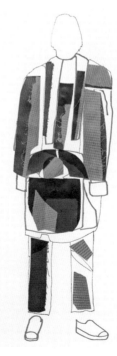

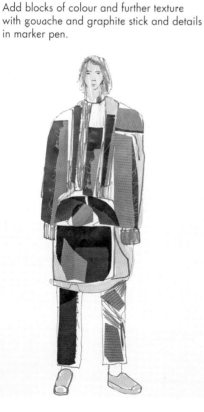

3

Tear and glue photocopied corduroy samples to add pattern and texture to the drawing. Think about the balance of colour, pattern and scale across the whole figure.

Student work

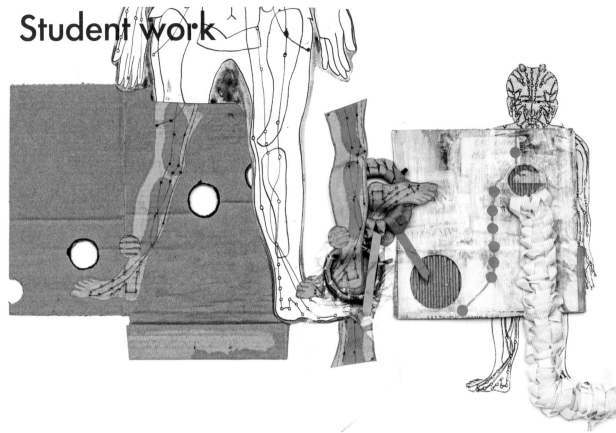

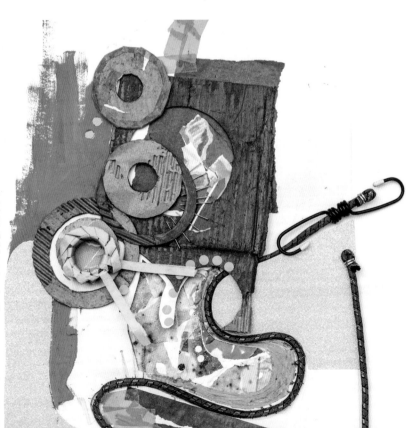

Yiyao Hu,
textile samples

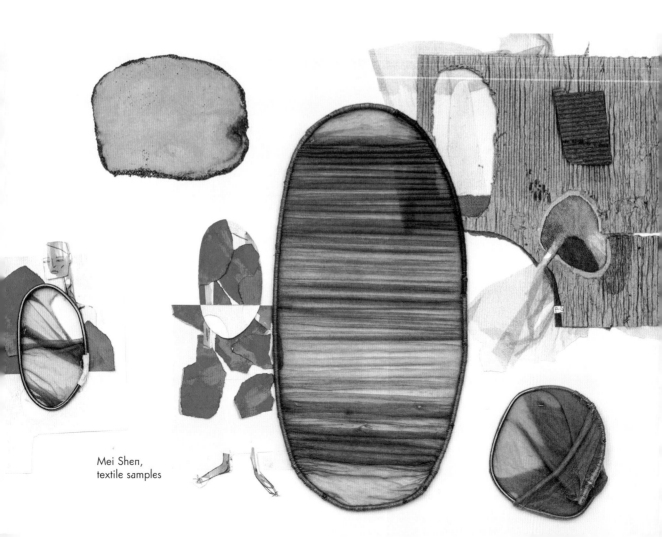

Mei Shen,
textile samples

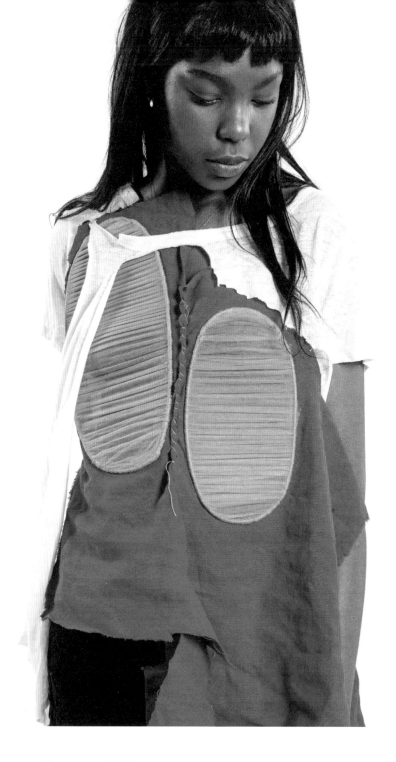

'I focused on the interaction between circular shapes
against repetitive lines. It was more of a print-based
project for me, so I mainly explored how
transforming my two-dimensional collages
and samples into tactile prints could inform
my garment constructions.'

Mei Shen

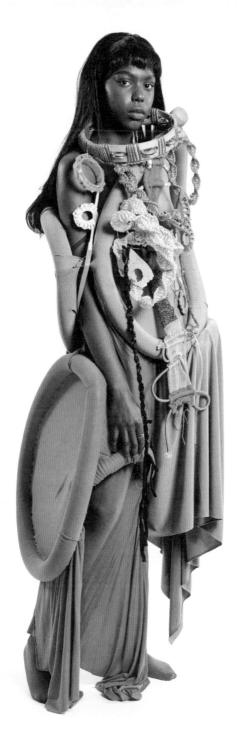

'I discovered that the Mandarin translation of the word "corduroy" comes from a type of plant used in traditional Chinese medicine. I began to explore body circulation and acupuncture points with a focus on circular shapes, as well as knotting techniques that are frequently used in cords and ropes.'

Yiyao Hu

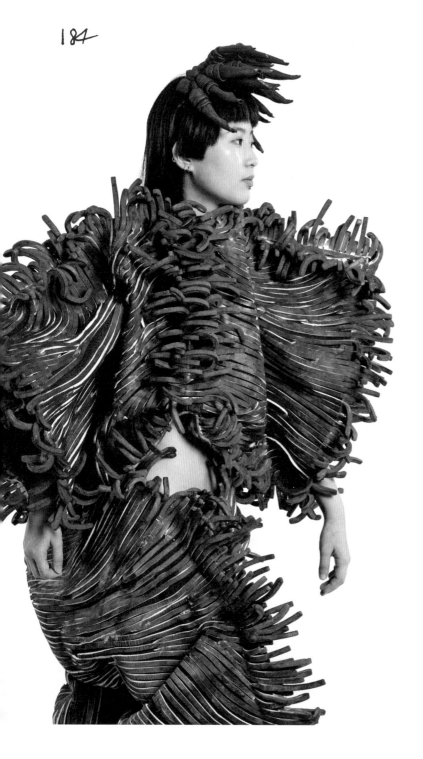

'Corduroy looks to me like wrinkled skin and also the
raked sand lines in Japanese gardens. I wanted to
use strong lines to change the shape of the body
and to make it more fluid. Working with sponge
I decided to explore the idea of a frayed edge so
the garment looks like it is dancing on the body.'

Natsuki Hanyu

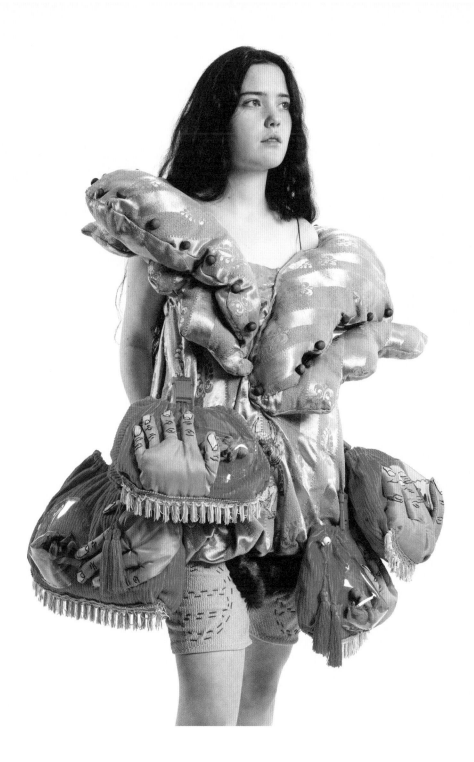

'I was inspired by Regency style furniture and upholstery. I wanted to show people the potential in taking a playful and decorative approach to design.'

Hannah Wright

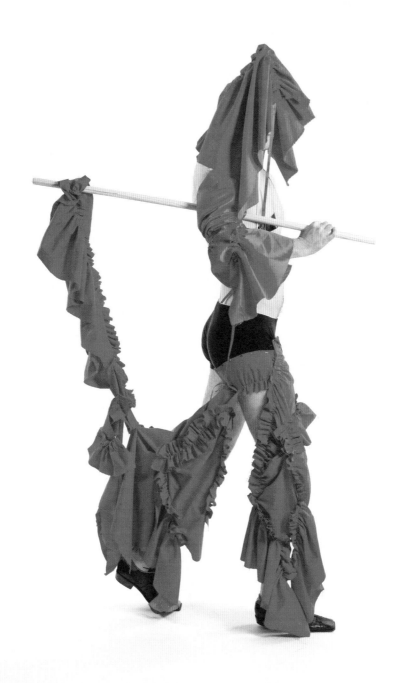

'The project is inspired by research into the history of corduroy in the eighteenth century, with a focus on raising awareness of how nature and modernity can be compatible. I aim to talk about the relationship between the human body and nature in an anatomical way, by deconstructing the layers of those subjects.'

Yuhao Chen

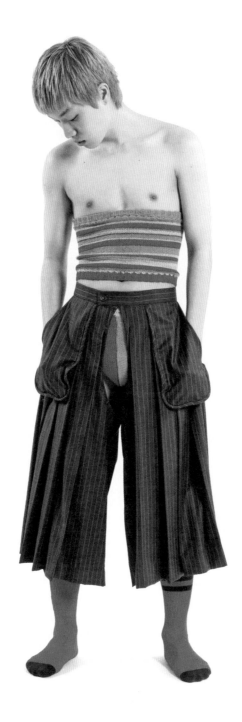

'My garments took influence from the lines that comprise corduroy and the concept of linearity having infinite possibilities of configuration. The knit pattern is generated from a random integer algorithm that uses atmospheric noise to build the sequence; it is rendered in primary colours as red, blue and yellow can form infinite possibilities of colour.'

Michael Stukan

Fine Art

Project Title: Site
Co-author: Karen Tang

Conceiving of, proposing and constructing a site-specific sculpture offers fine artists a demanding challenge that calls on a range of skills central to developing and sustaining a fine art practice. This project demands a direct interrogation of the formal, political, social and historical characteristics of a site in order to develop an intervention that actively creates a dialogue between the work, its site and an audience.

Context

'As I looked at the site, it reverberated out to the horizons only to suggest an immobile cyclone while flickering light made the entire landscape appear a quake. A dormant earthquake spread into the fluttering stillness, into a spinning sensation without movement.'

Robert Smithson, *Robert Smithson: The Collected Writings*, 1996

Sculpture is typically associated with three-dimensional form, material manipulation and object-making. In the latter half of the twentieth century, however, sculptural practice became increasingly inseparable from the space in which forms were conceived and exhibited. In her seminal 1997 text, *One Place After Another: Notes on Site Specificity*, Miwon Kwon says that site-specific art 'gave itself up to its environmental context, being formally determined or directed by it'. An example of this in practice is Rachel Whiteread's *House* (1993; destroyed 1994): a cast of the interior of a condemned terraced house in London's East End made by spraying liquid concrete into the building's empty shell before its external walls were removed.

Site-specificity can relate to different interdisciplinary practices, but the contemporary concept of 'site' has its roots in minimalist sculpture and how the audience 'performs' when experiencing it. In 1968, critic and historian Michael Fried said that 'the experience of literalist [minimal] art is of an object *in a situation* – one that, virtually by definition, *includes the beholder.*' This emphasis that the meaning of an artwork is dependent on the spatial act of viewing has been described as 'theatrical', bringing together sculpture and performance.

It opposes the idea that artworks have autonomous meaning; rather, the context in which they are experienced is as important as the objects themselves. For instance, a sculpture seen in a conventional 'white cube' gallery space in a city would present very different experiences and connotations for the audience if encountered in a desert.

In 1973, Daniel Buren's exhibition *Within and Beyond the Frame* took place in New York. A set of 19 banners, painted with Buren's signature stripes, was strung across the gallery and

continued out the window to the building on the opposite side of the street. Streets as a site have been explored by many other artists, including in Robert Smithson's photographic essay, 'The Monuments of Passaic' (1967), in which he analysed or 'mapped', the particularities of New Jersey's post-industrial landscape. Smithson's discoveries underpinned many subsequent site-specific sculptures he made around New Jersey, and later his iconic 'earthworks', such as *Spiral Jetty* (1970), now more commonly known as Land Art. The remote sites of iconic works of Land Art offered the possibilities of huge scale. However, Land Art does not require monumental gestures; see Ana Mendieta's *Silueta Series* (1973–80) where the artist used sculptural performance to insert her body into the landscape. Mendieta's oeuvre is imbued with powerful personal and political associations.

In thinking about making a site-specific sculpture, begin by looking further at the works mentioned above. What aspects of these works interest you? What conceptual, historical, technical and material research informed the creation of these works? If taken away from their site, how might these works change? Would they make sense or still be possible? Who might have encountered the works? You may discover that working in three dimensions is the most appropriate method of communicating; equally, your starting point could be an intuitive response to materials and space, or a combination of these two approaches. As you begin to make things on site, you might consider – and challenge yourself – with sculptor Richard Serra's unequivocal definition of site-specificity: 'To remove the work is to destroy the work.' What could this mean for your own work?

Brief

Your brief is to make an outdoor site-specific work that responds to and engages with a place within your local area. A consideration of your audience will be a vital part of developing your ideas.

For this project, our Foundation students made work for a park. However, the success of the site project does not depend upon creating work for a public space: it can be as fruitful for you to make work in a non-public environment.

Creating a site-specific work will require you to develop a wide range of skills in addition to your artistic vision and technical competence, including planning, mapping, organisation and negotiation.

Successful outcomes will result from a thoughtful and realistic attitude to material costs, fabrication methods and a consideration of scale. The mitigation of risk will be a vital factor in gaining permission for and acceptance of your work.

Step 1
Identify a site

Identify locations that spark your interest as potential spaces to interact with or add something to. Each site you identify should inform your thinking about the scale, material and form of a potential sculptural intervention. The current use of these sites, their aesthetic and historical narrative will be crucial considerations in assessing the suitability of your initial ideas.

Step 2
Site visit

Decide which site you intend to work with. Measure the site and make photographs and drawings, observing how it is used or interacted with.

Pay attention to the floor and any other features the site has: these will inform strategies for installing your piece. For example, are there places you might want to attach your work to?

Scale and viewpoint are inextricably linked to how your piece will be experienced in the context of this site. How do people approach and see the site? Can your work be seen from far away or is it in an enclosed space?

Step 3
Ideas generation

Print out your site photographs and pin them and your site drawings to a wall along with two blank sheets of A2 paper. Begin by clarifying in a few words the ideas and associations you have with the site, then translate these ideas into as many drawings as possible. Standing up to sketch ideas is a way of bringing an urgency and physicality to the visualisation process. Do not worry about whether the ideas are practical or will be successful – the point is to think and draw freely.

Step 4
Refinement, audience and logistics

Decide which idea to take forward by considering the following practicalities:

- **What materials and tools do you have access to?**
- **How much will it cost to make your work?**
- **How will your work be affected by the weather?**
- **How will you make sure your work is installed, fixed and secured safely?**
- **Who will be your audience, and is your idea appropriate for them?**

Now interrogate your chosen idea through further drawing, varying the media you use to refine your ideas about weight, material, colour and form.

Step 5
Create a proposal

(See p. 194 for guidance on this.)

If the work is situated outside the boundaries of your home, use a proposal to seek the relevant permissions before installing your work.
It is your responsibility not to alter your site permanently (unless you have permission).

Step 6
Fixing strategies

Decide how you will install your work, as this will often inform the construction.
Fixing strategies for outdoors might include:

- **Weighting your work with a wide base in timber or metal or working with heavy materials such as plaster, concrete, bricks or, for very large work, a welded steel armature.**
- **Attaching your work to a fixed structure using builders band, bolts, ratchet straps, strong rope securely knotted, a chain with padlock or large cable ties.**
- **Built-in anchor points using auger stakes or tent pegs, tension cables, hooks screwed into your structure or bamboo sticks sunk into lawn/flowerbeds.**
- **A floating object can be anchored with rope or a weighted armature using sand ballast.**
- **Printed vinyl for installing on windows or smooth walls or floors.**

Step 7
Make the work

Select materials to work with that are cheap, safe, weatherproof and stable.

Use: Bricks, breeze blocks, Styrofoam, strong plaster such as Crystacal R, concrete, timber, plywood boards, 13mm chicken wire, bamboo canes, expanding foam, fibreglass, scrim, old bikes, oil drums, outdoor furniture, garden equipment, exterior paints, yacht varnish, weatherproof fabrics such as AstroTurf and natural materials such as rocks and branches.

Avoid: Offensive content, digging, damage to trees, sharp edges, materials that can blow away and anything that you will be devastated by if it gets damaged or destroyed.

Step 8
Document then deinstall your work safely

Take good photographs of your work from many different angles.

How to create a proposal, with Adrian Scrivener

Writing a proposal

The purpose of a proposal is to describe a work that an artist would like to make to another person or people whose assistance or permission they might need. It is an essential tool to convince third parties in control of spaces of interest that you are serious and professional. It also forms the starting point for the subsequent development of the work, both conceptually and practically.

A good written proposal should in as few words as possible describe:
- What you will be producing (that is, its form and the materials expected in its manufacture).
- Where the work will be sited (indoors or outdoors and at which specific location). If applicable, mark your site on a map.
- The way it might work over time or with audience participation (for instance, will it rotate freely in the wind? Will people be able to touch it or take it away?).

A proposal is not concerned with:
- Explaining the meaning intended with the work.
- Outlining context relating to previous works or ideas.

Creating a visualisation

A visualisation is often used alongside a written proposal and is another tool with which to convince relevant third parties of the value of your idea.

The most immediate way to make a site-specific visualisation is using photography and collage – either working directly with scissors and glue or with basic digital compositing. Christo and Claes Oldenburg are artists who have used these techniques to good effect.

Ana Garcia Hoefken, visualisation for site-specific sculpture

How to carry out a risk assessment, with Adrian Scrivener

A risk assessment is a methodology that identifies the potential risks and hazards that may occur in the production, installation and exhibition of an intended work, with a view to allowing the work to be possible. This is known as mitigation of risk. The methodology follows a series of stages:

First stage

- Identify all risks. These could range from a danger of falling from a ladder during installation to a risk of fire as a result of the use of a flammable material.
- Identify to whom the risks apply. For example, the artist/ producer, people involved in the installation of the work or the audience at the exhibition.

Second stage

- Outline what is intended or is already being done to minimise or mitigate the risks. For example, working alongside someone else who can hold and stabilise a ladder to reduce the risk of falling.
- Outline further actions needed, such as spraying flammable material with fire-retardant spray. It is helpful at this stage if you can have a discussion with a tutor, technician or other professional (health and safety advisor, site manager, structural engineer, etc.)
- Indicate who is responsible for each action and at what stage of the project it is required.

Third stage

At specified times, monitor that the actions identified in the risk assessment are being followed.

Student work

'In wrapping the bridge I wanted to highlight its form, transforming it into a feature in its environment.'

Sisi Turner

'I am interested in how soap has qualities of removal or cleansing. Also how it holds the potential to be shaped by its environment; if it rains the edges will smooth. Eventually it will disappear.'

Dorothy Zhang

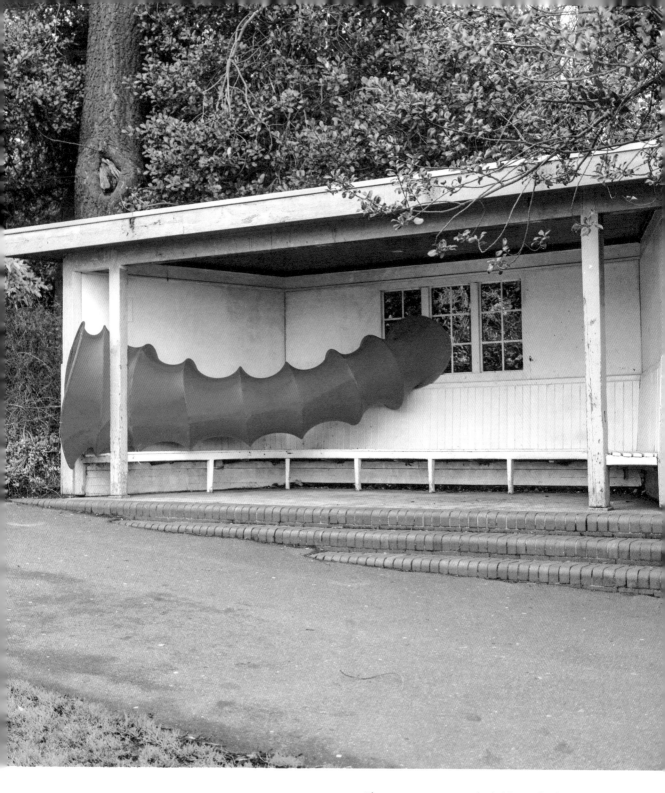

'This piece appropriates the hidden and unknown spaces of its surroundings. The anthropomorphic tunnel draws on the human curiosity of the viewer, making them question what it leads to and what's inside.'

Megan Ajioka

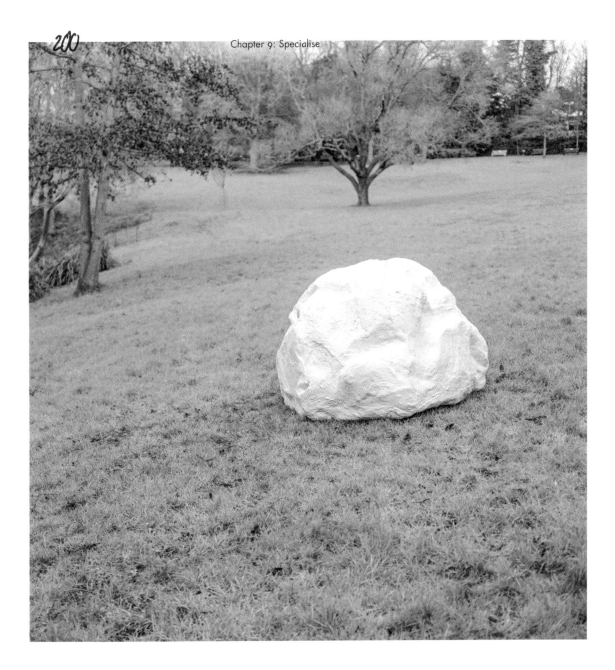

'I was fascinated by the idea of an unnatural object finding its place in a natural environment. The bright yellow blob stands out in its fairly colourless autumnal environment but at the same time, due to its organic structure, seems quite at home in the landscape.'

Meera Madhu

'Waterlow Park has a connection to refugees and tolerance and I saw an opportunity to draw attention to Britain's recent decision to split from the EU and reflect my concern about the wave of intolerance in the Western world.'

Hampus Hoh

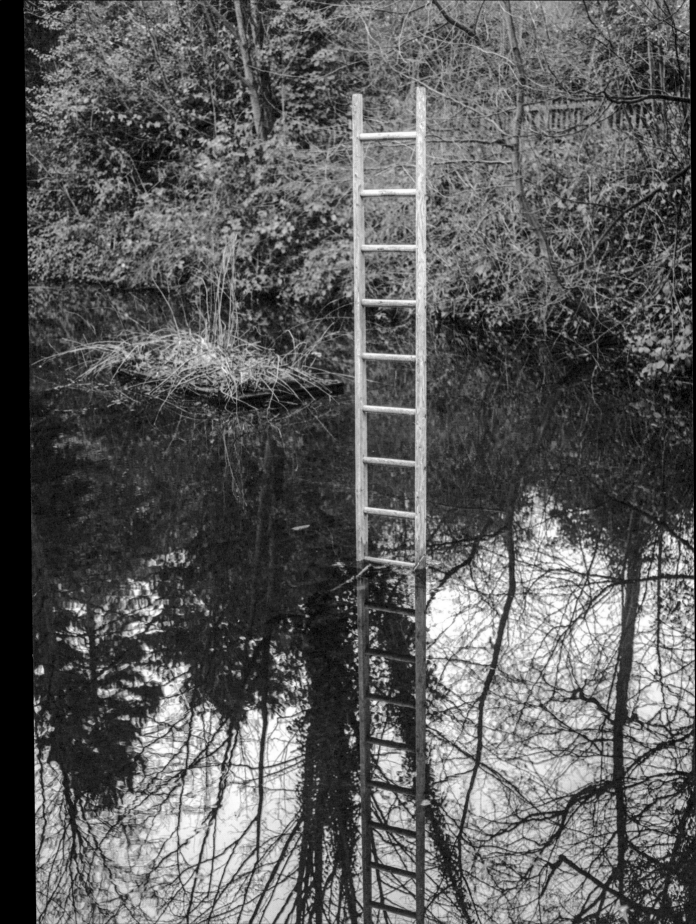

Three-Dimensional Design

Project Title: Into the Wild
Co-author: Georgia Steele

This product design project is inspired by contemporary urban relationships with the natural world and acknowledges the power of the wild to positively affect our lives.

The ability to identify a need and profile a target audience is of vital importance to all designers of products. The challenge of this project is to connect craft skills and material sensitivity with desirability, while also prioritising functionality and sustainability.

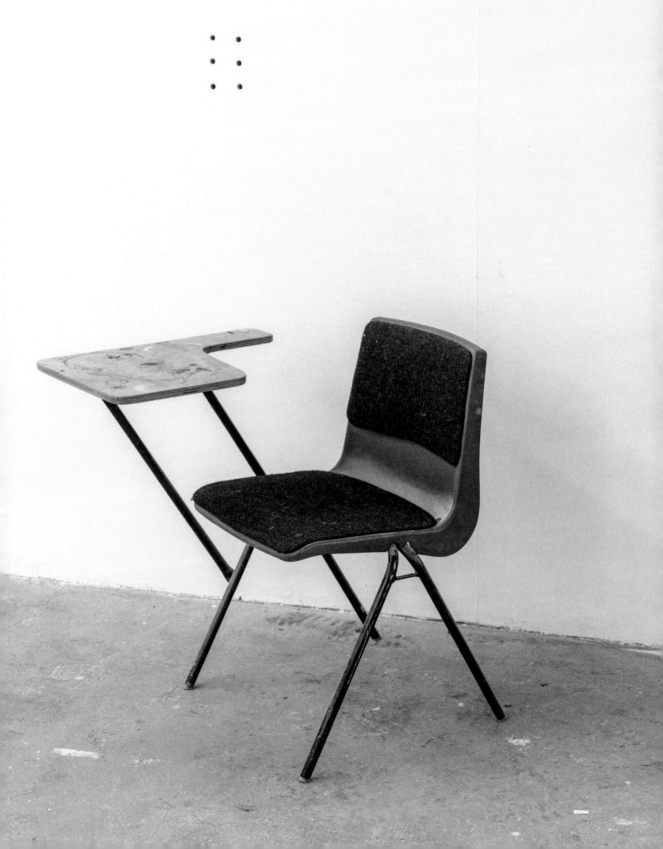

Context

Product design is the process of developing new products to enhance or transform people's lives. Functionality is balanced with aesthetics, and innovations are informed by an understanding of materials, manufacturing and how the product will be used.

There is compelling evidence to suggest that with access to nature or even just a view of trees, elderly adults tend to live longer, college students do better in cognitive tests, children with ADHD display fewer symptoms and pregnant women have lower blood pressure. It is alarming, therefore, to realise that children's access to the outdoors is rapidly decreasing and that some communities access nature significantly less than others. According to the United Nations, over half the world's population live in urban areas[1] and this is set to keep rising. For all but the most wealthy, urban living increasingly means less access to outdoor space.

Design has a role to play in responding to this data. Designers can create solutions to deepen the intensity of experience with nature for those who already access it and, perhaps more importantly, can encourage and facilitate an engagement with the outdoors for those less able or inclined to interact with it.

You will need to consider the environmental impact of any product that you design, especially in a project that celebrates nature. By using sustainably sourced, local or recycled materials you can reduce environmental impact; equally, sometimes a hardwearing material that requires less maintenance can be a more sustainable choice in the long term. Environmentally sourced materials could also provide inspiration and affect the form of your designs in a positive way.

Sustainability is social, and good design can support the health, wealth and happiness of communities. The physical and mental health benefits of getting outdoors for fresh air and natural light are very well documented but walking or cycling to work, exercising a dog or taking children to the playground can also make it easier to become part of a local community. Your focus for this project could be to look at social barriers to outdoor engagement, for example, by tackling parental fears about child safety or aiming to bring strangers together to develop a sense of community in urban outdoor spaces.

A wealth of designed products, from activity trackers to folding chairs, already cater to a group of users who regularly access nature, and so common-sense solutions to enhance engagement and enjoyment for this target audience will face stiff competition. When approaching this project, remember that design has the ability to shift behaviours and instigate positive change. Aim to use your research, contextual insight and empathy to identify and address a genuine need.

You are not required to devise complex or technological solutions. Look for opportunities to make small adaptations to existing products or to develop simple solutions that could make a real difference to the lives of the people who use them.

1. United Nations, 'The World's Cities in 2016'
www.un.org/en/development/desa/population/
publications/pdf/urbanization/the_worlds_cities_
in_2016_data_booklet.pdf

Brief

This project is about the transformative effect of nature. Your brief is to design something that encourages and enables outdoor experiences. Personal experience of outdoor activities and primary research at a specific outdoor site should inform your ideas. Secondary research into the science and psychology associated with access to nature as well as into existing products and materials will also be useful as you develop your design.

Your designs should explore, embody and promote an appreciation of the environment through effective design, using sustainable materials and principles.

Step 1
Site visit

Choose a local public outdoor space to visit. Take photographs and make notes and sketches. Observe what people are doing there and think about what they could do there. Survey the products that are already being used. Capture your own positive and negative experiences. Pay attention to the people you do not see there as much as to the people you do.

Step 2
Idea generation

Use your observations from the site visit to help you develop your ideas. Identify positive aspects of the place and activities that you observed – you could look to enhance these with your design. Also, look for problems that you could solve. Work quickly at first, making rough sketches and generating as many ideas as possible.

Step 3
Identify your end user

Identify a group of users, such as children, runners or the elderly, and focus your project on them.

(See How to create a user profile on p. 208.)

Your product should facilitate an outdoor activity, from sport to foraging for wild food, for your chosen group. Consider what a fulfilling experience might constitute; think about the equipment needed and the barriers that currently affect this activity. Look at your group's specific requirements, interests and capabilities. By observing and understanding human behaviour and the human body, you can make sure that your designs are practical.

Step 4
Explore materials

Look at the materials that are being used at your location. Evaluate how they look and how they perform. Consider texture, colour and the impact of weather conditions. Decide whether you want your product to complement or contrast with the surroundings.

Step 5
Sustainability

Consider the sustainability of your designs. Research environmentally sustainable materials and social benefits. Look out for indigenous materials that could be used, or ways that your ideas could engage with the community. Local or open-source manufacturing can also help sustain local economies.

Step 6
Draw your design

When you have focused on one product idea, draw your design in detail. Show different angles and any adjustable or interactive features. Add measurements to show the scale and annotations to explain material choices and any special features.

Step 7
Create a model

Three-dimensional models can help you to explore your idea. You don't need to use the actual materials that you intend to use for manufacturing – you can use cardboard or scrap materials.

Step 8
Create a visualisation to show your final design in use

You can create a visualisation by hand using drawing or collage, or you can use digital photo-editing software. Show the design being used by your identified user, and place your image onto a photograph or sketch of your location to show the context.

How to create a user profile, with Tom Nelson and Kathleen Hills

A user profile is a composite of observations, characteristics and images that represents a wider group of users and helps the designer to better understand their needs.

Task

Observe and record information about the habits, behaviours and experience of typical users of a wood or park near you. Who or what do they engage with? How long do they spend there? What are they wearing or using? What might be the intention of their activity? What aspects of the environment are they missing out on or not aware of?

Think about the needs of the people you observe and their chosen activities. How is design already assisting their engagement with the wild? What might be missing from their experience? You should also consider who is not there and think about what might be prohibiting them from accessing this space.

Think of a design question for each person you observe and record.

Examples

Observation

Children are using found materials (sticks) as tools for play.

Their play is limited by the children's size, strength and coordination.

Question

How can you encourage play in the woods while also protecting the environment from damage?

Children playing in the woods

Hiker

Dog walker

Older woman sat on a bench

Woman jogging in a park

Student work

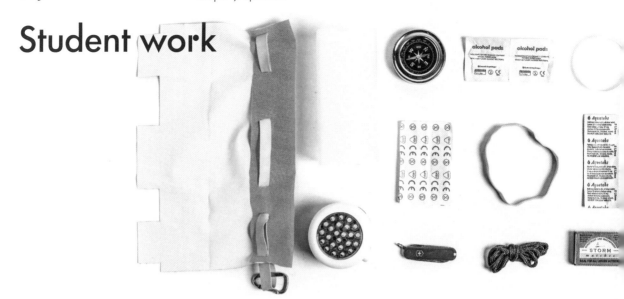

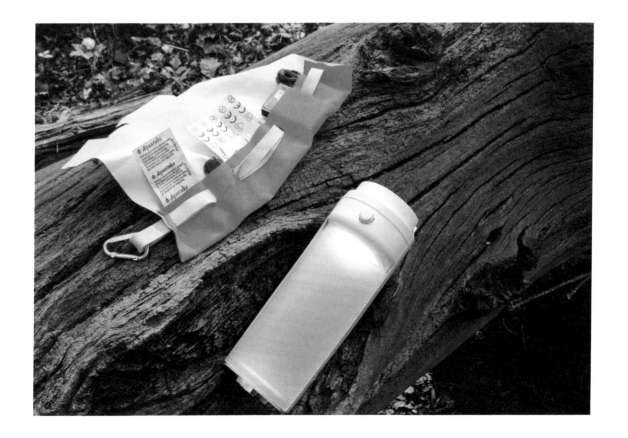

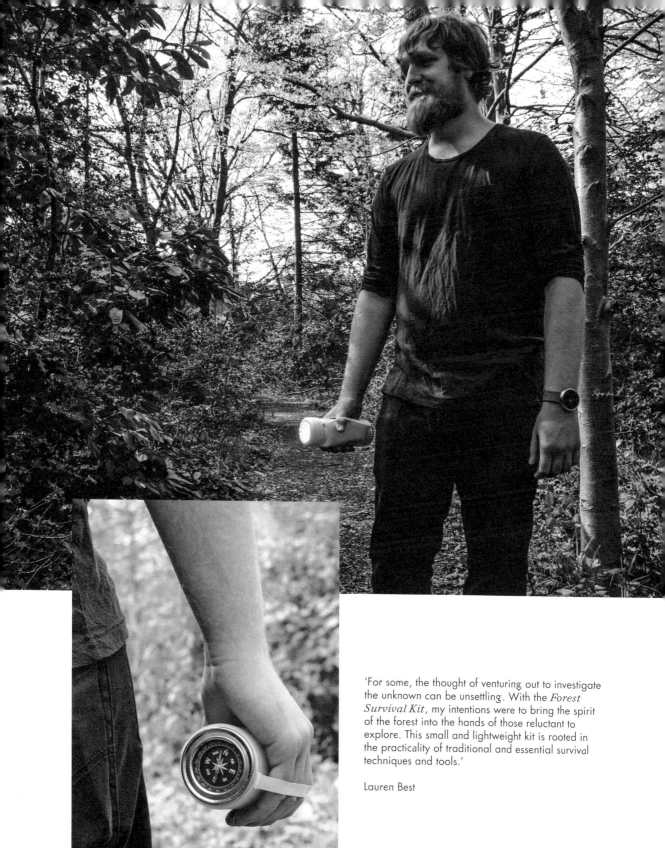

'For some, the thought of venturing out to investigate
the unknown can be unsettling. With the *Forest
Survival Kit*, my intentions were to bring the spirit
of the forest into the hands of those reluctant to
explore. This small and lightweight kit is rooted in
the practicality of traditional and essential survival
techniques and tools.'

Lauren Best

'These footwear pieces transform the familiar activity of walking into an entirely unfamiliar experience, leaving the user's mind unusually focused on this everyday task. The pieces are designed to be worn by someone who wants to experience the unusual and escape the mundane.'

Carina Eke

'My piece helps individuals to protect themselves
against the threat of anxiety which leads a person
to perceive their environment as unsafe. It draws
inspiration from animalistic defence mechanisms
and medieval armour.'

Imogen Colla

'This Desk Divider is intended for office workers who might not have time or opportunity to go outside during their working day. As well as creating a private space to work, it can also be used to bring the natural world into the workplace.'

Garret Peiyang Liu

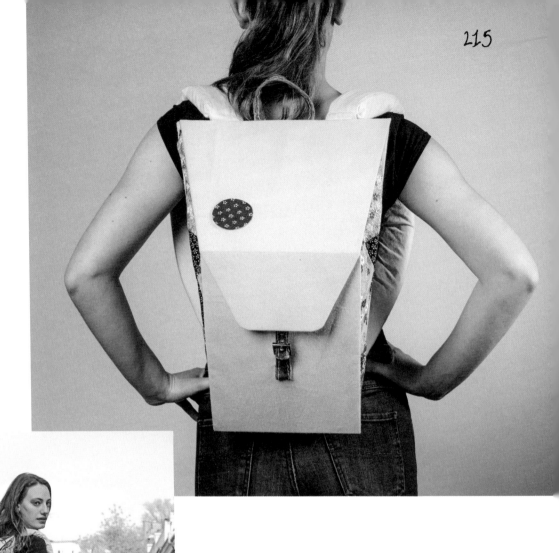

'The *Urban Explorer* is an environmentally friendly backpack designed as a direct response to the city dweller's need for adventure. Made from repurposed foam, leather, wood scraps and strong calico, its ergonomic and dynamic shape enables the user to move freely while simultaneously hugging the natural spinal curve with a padded back.'

Eva Jane Gates

Chapter
10
Collaborate

'I think that much of the input that has always come into me has come through relationships with people I know...You are constantly being fed with – depending on how open you are – many new ideas...We are each other's sources.'

Corita Kent, in Corita Kent and Jan Steward, *Learning by Heart: Teachings to Free the Creative Spirit*, 1992

Becoming successful in the world of art and design generally depends on artists being able to work effectively with others. This could involve working collectively to generate ideas and being part of a team that develops those ideas into workable solutions. Or it could mean collaborating with other people in the production of work.

A compelling example of how shared experience can cultivate deeper understanding comes from the Japanese art collective The Play, whose members have been working together since 1967 to create events and actions that foreground aspects of endurance and improvisation and embrace risk and failure.

On 20 July 1969, The Play began a 12-hour journey from Kyoto to Osaka, floating down the Uji, Yodo and Dojima rivers on a 3.5 × 8m arrow-shaped Styrofoam raft inscribed with the words 'the PLAY'. Over the last 50 years they have come together repeatedly to carry out similarly playful explorations of self, community and nature. This included building a wooden tower on a mountain in Kyoto then waiting for lightning to strike. This project was carried out repeatedly over a period of 10 years.

Our approach prioritises the social experience because, like The Play, we believe that as you undertake collective working, making and improvisation, your own practice and ideas become enhanced and critically informed by the actions of the group. Tim Beard of design studio Bibliothèque reinforces this: 'design is a social process with social outcomes'. He believes that dialogue and discussion of the production of the work – both within and outside of the studio – is vital to its success.

There is a commonly held misconception among our students that in order to produce work of note that has something to say to many people the inspiration for that work should somehow be found elsewhere. We see huge value and potential in the ideas that spring from somewhere very close to home, placing importance on the knowledge and experience that you hold within yourself and that you can access from your peers. To quote artist and educator Corita Kent again: 'We needn't search for a source to start our work; sources are all around us.' A topic that you have an intimate understanding of can be a rich starting point for your creative work.

This project asks you to take forward Kent's assertion that 'we are each other's sources', using your peers to help you to expand your exploration of the potential of your perspectives on the world. Through this intense and immersive process, we hope that you will nurture existing ideas, stumble upon unexpected possibilities and open up to completely new avenues of enquiry. We also hope that you find new friendships or deepen existing ones, build a network of practical help and support and begin to construct a critical discourse with your peers.

Brief

This is an intensive and highly experimental research process exploring a collective approach to generating ideas and opening up new possibilities for the production of work. It involves living and working with two other people for a period of three days and two nights.

Ask two friends to undertake this project with you and together identify a location to inhabit. You are each responsible for one day of the experience, using the knowledge, experience and practical abilities of your peers to explore a starting point that you define for yourself.

In your group, you will be called upon to write a manifesto that states your aims for the experience and sets out a series of guidelines that you will observe for the duration of the project.

Step 1
Form your group

Form a group with two others with the intention of working together for a period of three days and two nights.

Step 2
Identify a thematic to work with

Each participant should think individually about what they would like to explore during the project. It is important that you choose a subject or theme that you can observe, experience and attempt to know more fully.

Step 3
Identify a location

Together, think about where you would like to locate your project. This could be anywhere from your garden shed to a rented apartment far from home. Consider how your location relates to the ideas that each of you is interested in exploring. Consider also how the location could enforce interesting constraints, dictate a shift in working practice or change your point of view.

Step 4
Develop rules to live by

Together, dedicate two hours of your time to deciding on a set of rules for the project. You should consider the following:

- **How you will structure your days (times for getting up and going to bed, mealtimes, times for work, leisure, discussion, etc.)**
- **Whether you will build in any constraints. You could limit mobile phone use, explore working in silence or working with duration, repetition or free association.**
- **How you will make decisions (for example, roll a dice, vote, assign a leader).**

Step 5
Write commune manifesto

Together, write a manifesto, outlining the following:
- **A statement of intent: one sentence that summarises your project's principal focus and purpose.**
- **Three points that address the following aspects of your experience: practical (for example, the working day, how you will use the location), social (or how you will facilitate the social aspect of the experience) and methodological (how you will work and how you will use each other during the experience).**

Step 6
Design a set of collective actions

Individually, design a set of potential activities that will engage the three members of your group in an experimental way during your allocated day. Consider structure by allocating approximate periods of time to different activities and clarify a set of aims for your day.

This structure does not have to be rigidly adhered to – there should be room to be spontaneous and responsive – but it is a starting point that will help to provide focus and direction. Outline how you plan to use the unique and different skills and perspectives of your fellow group members to further your own ideas.

Step 7
Pack and prepare

Gather any materials you anticipate needing for the activities of your project. If it is taking place away from your home, pack what you will need for the three days and two nights.

Step 8
Collaborate

Go into the experience wholeheartedly; embrace the opportunity to connect with others, to experience their perspective on the world and to allow them to expand your outlook. Document everything you do using your sketchbook and a camera.

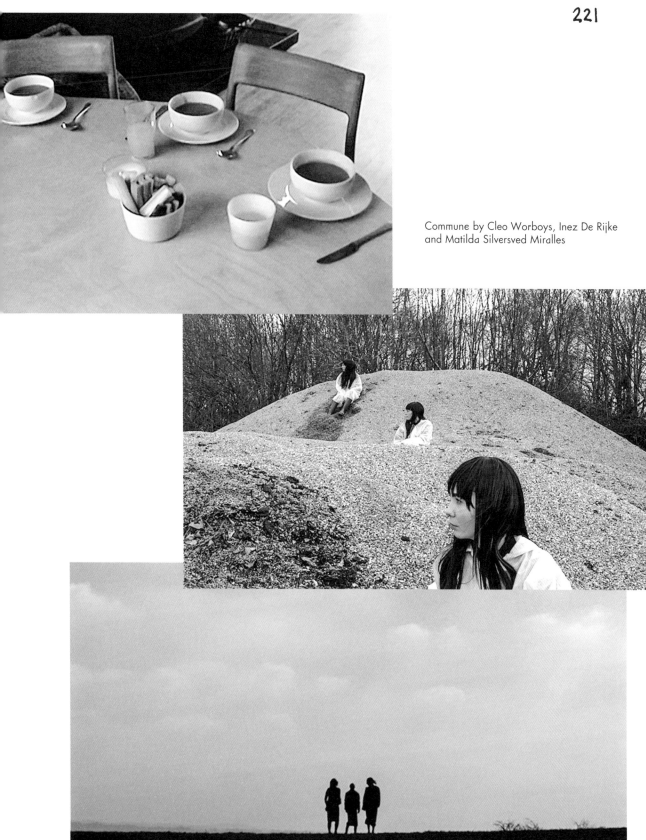

Commune by Cleo Worboys, Inez De Rijke and Matilda Silversved Miralles

Commune in the Futuro House

In April 2017, four Foundation students undertook their collaboration project in Futuro House, which was temporarily situated on the roof of Central Saint Martins. The Futuro House was designed by Finnish architect Matti Suuronen in the late 1960s and was intended to be a ski cabin that was straightforward to produce and easy to assemble, dismantle and transport. The four students were in continuous residence from 11am Tuesday 18 April until 5.45pm Saturday 22 April and took in all they needed to survive and make work throughout the duration of their stay.

The Futuro House received its American launch in July 1969, the same year as the Apollo 11 space mission. This was also the year of the 'Locked Room', a now-famous educational experiment at St Martin's School of Art in which a group of sculpture students were locked in their studio daily for eight hours throughout a term, with restricted materials and no critical feedback from tutors.

Commune in the Futuro House was an invitation to explore a collective approach to generating ideas about the future by living differently for four days, six hours and 45 minutes; the period of time that the Apollo 11 space mission took to reach the moon. The participants (Celine Clark, Amy Packwood, Scene Peng and Isobel Whalley Payne) each produced a body of work during their residence in the Futuro House, which reflected their experience of living and working in this intense and creative environment.

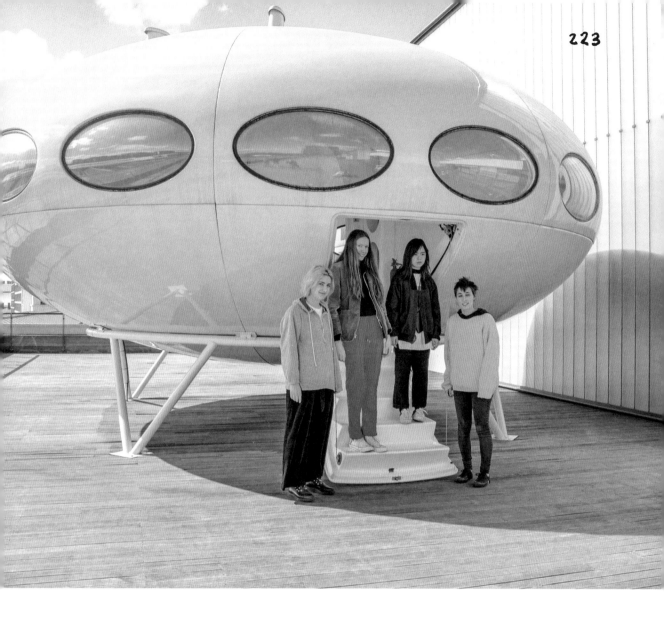

What motivated you to put yourself forward for this experience?

We were talking about the 'Locked Room' experiment at St Martin's in the 1960s where the students were shut in their studios for a term with very little stimuli. I am interested in how that might encourage me to create work that is very personal and taps into my inner world and imagination. There is definitely a process that once you start doing something with your hands, things start developing.

Celine Clark

I am really fascinated with strangers and strange places. I want to take time and sit down and have conversations with people. I feel like in my daily life I have a very short time with people and we don't take time to enjoy being together.

Scene Peng

Can you describe the experience of living and working in such close proximity to three others in the confined space of the Futuro House?

I think from the moment we stepped through the door of the Futuro House we started trusting each other. Because if you live in a really strange environment and you're working there, you have to trust the environment first in order to focus. And I think for me the other participants were the environment.

Scene Peng

We all spoke about how the space was almost like a mind and everything we put on the walls and all the clutter around us was like a manifestation of everything we had thought and experienced together.

Celine Clark

It was much easier to work at night because you were completely cut off. In the daytime you could see out of the windows to nearby buildings and the people walking around outside St Pancras station. But at night, it was completely dark and it was like the Futuro House was the whole world for us then. It was much easier to make strange and absurd work in that cut-off space than it would be in the outside world.

Amy Packwood

It made me make things more practically from my own head instead of constantly looking at things and responding to outside influences.

It felt really intimate in that space and I wouldn't have got to know people in that way if I hadn't undertaken that experience.

Isobel Whalley Payne

I developed a lot of ideas about what I was interested in as a whole, and what I was doing in the House gave me more understanding about what I want to do in the future.

There was definitely a sense of our work overlapping and we bounced off each other and helped each other out with different ideas. We didn't come up with something together, it was more like our projects ebbed and flowed into each other.

Celine Clark

= YOURSELF WITH DEEPSET EYES AND FIN

OPEN CLOSET DOORS AND DIGS

BIBL

K NESS OF MY HEAP AND MAY HE COLOUR O

I HAVE LEFT NO TRACE HERE
DO NOT LIE TO ME
YOU ARE ALL TOGETHER COLD
BUT COLD AND SURROUNDED BY
THINGS NOT JUST ENDLESS
LANDSCAPES WHERE MADNESS
RUNS FREE AND SLITS THE
THROATS OF THOSE WHO
LOVE THEM

THE DESERT IS MY FAVOUR

(S)HOT AND STR

PLAN D V

AND A

DADDY
PULP
ENVOI
EASY
DUBBY
WALL ST
RIVER

CHEAP
GIRLS

Chapter

11

Initiate

You have now worked through a diagnostic course of study in which you have explored a broad range of art and design disciplines and have tackled a range of subjects, themes and issues. The final stage of the Foundation is to self-initiate a project that explores your own concerns through the lens of your emerging disciplinary focus.

Initiating work without an external brief is fundamental to an artist's practice, and increasingly designers too are carving out significant time to make self-directed work. Such projects offer designers and design studios a space to explore more speculative ideas and to stimulate innovation. They are also a way of initiating public and industry debate, engaging with more overtly personal or political themes and building the identity of a design practice.

If we look at the following three examples of students self-initiating work, you can see the importance of these projects in helping to establish a distinctive approach, set a personally relevant agenda and provide a platform for self-promotion.

In 2010 a collective of mainly architecture students and graduates working under the name Assemble transformed a derelict petrol station in London into a pop-up cinema enclosed by a theatrical curtain hung from the forecourt roof. *Cineroleum* aimed to demonstrate the potential for repurposing the 4,000 disused petrol stations in the UK. The project captured the public imagination and gained huge design industry interest, effectively launching the group's career. Five years later they won the Turner Prize.

At the age of 17, Amelia Dimoldenberg started a journalistic project called *Chicken Shop Dates* for a column in the youth magazine *The Cut* where she interviewed grime artists in chicken shops around London. Dimoldenberg sustained this project during her demanding Foundation year and subsequently set up a YouTube channel while she was studying for a BA in Fashion Journalism at Central Saint Martins. Before graduating she won the *Guardian* Broadcast Journalist of the Year award and in 2018 fronted her first primetime documentary, *Meet the Markles*.

A group of interns at the Mexican firm Estudio 3.14 designed and visualised a *Pink Prison Wall* celebrating Mexico's architectural heritage in response to the US President's plan to build a wall along the border between both countries. The project, which saw a commercial practice enter the political arena, received significant exposure internationally.

These are just a few examples of how creatives at the beginning of their careers made non-commissioned, self-initiated work that enabled them to develop their creative voice and make an impact.

Tips for writing your own brief

Think about how you would like to extend your practice. What have you responded to so far in terms of subject matter, disciplinary focus and methodology? What are you interested in or excited by?

The projects in this book all use different approaches for initiating projects, which should have provided you with a range of strategies that you can now apply to writing your own brief. The Made to Persuade project asked you to begin by identifying something that made you feel annoyed or angry; the Site project started with a particular place to respond to and intervene within; Into the Wild introduced the idea of an end user and a system of user-profiling as a way of identifying a need; and Material Restriction began with the exploration of a material, responding to its history, construction and aesthetic.

Designing a project that can sustain your interest and enquiry over a period of time requires a starting point that is both specific and immediately available to you. You need to be able to draw on direct experience when initiating a project, so choosing ideas, objects, spaces and experiences that you have access to is vital.

Brief

Identify something that initiates action, an idea that you can immediately respond to practically by making and testing. Although secondary research and information-gathering is vital for the creation of well-informed work, it can inhibit production if given too much weight and emphasis.

Below is a series of steps that will help to set you on the road to a successful self-initiated project.

Step 1
Identify a theme

Your theme is defined here as your broad area of interest. It is a notion that you feel excited by the prospect of exploring in your work. Examples might be: silence, narrative, protest. Choose a theme that is open-ended enough to allow you to subject it to a variety of processes, materials and restrictions, but directed enough to allow your own particular viewpoint on the subject to be the focus.

Step 2
Identify a subject

Your subject matter is the particular content or aspect of your theme that you intend to explore which will give you a specific starting point and frame of reference. For example, if your theme is storytelling, your subject matter might be overheard conversations or graphic novels.

Step 3
Write a proposition and choose a title

Take a stance or identify a position to explore or push against. Clearly frame your project and the motivations for your enquiry.

Step 4
Define success. What are you trying to achieve?

What does success mean for your project? What are you trying to achieve in making your work. Who is it for and why should they care? These are tough but essential questions to ask at the outset so that you have a clear set of intentions to test your work against. Remember a gallery exhibition is not the intended context for most design work, so thinking about where your project will exist in the world once complete will help guide your decisions.

Step 5
Decide upon a timeframe and write a time plan

Perhaps counter-intuitively, restrictions and structure can be hugely liberating. Give yourself a timeframe to work within that is realistic but that also allows for the production of ambitious work. Important considerations are: access to your subject matter, technical facilities available and, if appropriate, timescales for external production.

Step 6
Identify a range of research sources

This is not about determining the whole research journey since this will be ongoing and informed by what you encounter along the way. It is about identifying a context to begin working within and a range of initial sources to access. What are the key theoretical concepts you are interested in? Which practitioners make work in this area? What parallel fields might inform your enquiry?

Step 7
Find your starting point

What media and process will be your way into this project? This is not a written dissertation – it is a process of making and doing and it is essential that from the outset you identify practical ways to explore your ideas and interests. It is vital that you don't try to think too far ahead – you should not be thinking about outcomes at this stage, but you do need tangible beginnings to start your iterative process.

Step 8
Test it out (project in an hour/day)

Early in the project, regardless of the overall timescale you are working to, you will need to compress the whole project into mini versions of itself using simple resources. This is a process of testing out the parameters and the viability of your project and instigating first steps that will trigger continued lines of enquiry. Try making your project in one hour, then try making it in one day responding to your first test. See what is possible with what is at hand and without overthinking.

Step 9
Make

We suggest a timespan of three to six weeks for the making stage of this project. This duration allows for the evolution of your ideas over time, for an in-depth and active research process and for testing and refining your work as you move towards an outcome or series of outcomes.

How to begin

Beginning a project can be difficult. It can be tempting to get caught up in the research and planning stage, turning ideas around in your head and mulling over possible starting points. We advocate a beginning where you quickly challenge yourself to transform your ideas into something tangible. It is about moving from 'what will I do?' to 'how will I make that better?'

Set out opposite is an exercise designed to remove procrastination and hesitation.

Exercise: 1m²

'We cannot afford to waste time and material. We must make the best we can out of what little we have.'

Josef Albers, quoted in Eckhard Neumann, *Bauhaus and Bauhaus People*, 1993

This exercise will help you explore how your ideas and concerns might find form and function in the world. Over three hours, you are asked to fill 1m² of space with an expression of your idea. You are restricted to the use of a single material (plus paper if you need it). Materials could range from pens or paint to electrical tape, tiled photocopies, light, projection, plaster or your body.

1

Select a space and define the 1m² within it that you are going to work with. You can delineate it using tape if you like.

2

Decide on your approach. Will you make something three-dimensional that explores metaphor or hybrid ideas? Will you respond to something that already exists within your 1m² of space, applying your material to transform the environment?

Keep it simple – this is about approaching your project in the most straightforward, pared-down way.

3

Make. Don't allow yourself to consider anything outside of your 1m² or to project your thinking beyond the three hours of time allocated to this project. Become involved in the process of making, responding only within the constraints of the task you have set yourself.

4

Reflect on what you have made and plan your next step. Very often this exercise can help to determine the direction of your project going forward and can serve to initiate more substantial and involved project work. Consider how you can refine what you have done: will you work with different materials more appropriate to your concept? Will you work at a different scale? Will you place your work in a different context?

Student work

Three-Dimensional Design

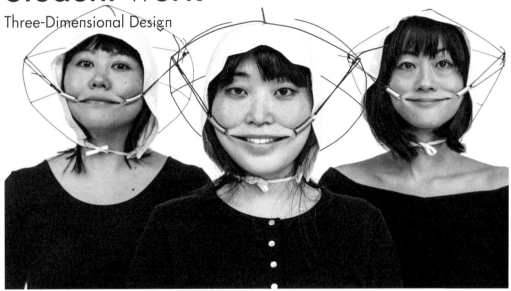

'The physical and psychological oppression of women can appear normalised so that they often do not recognise the abuse inflicted on them. My work references this normalisation through the "forced smile", and the design is influenced by traditional torture and public humiliation methods for women, such as the scold's bridle.'

Holly Beighton

'My work is aimed at people who aspire to a clear and calm space. It intends to transcend the cluttered and urban city lifestyle, creating an oasis of calm by utilising natural elements, attributes and materials.'

Rowena Potter

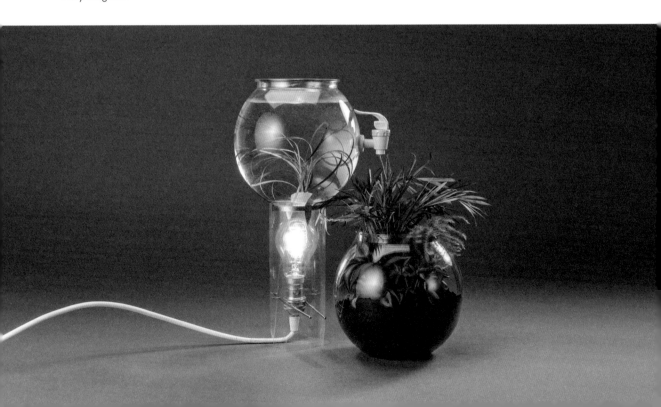

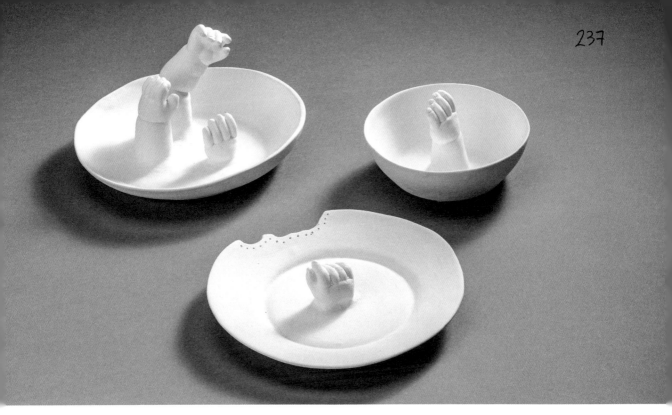

'This project prompted an exploration of the concept of belief systems and how people use them to help and guide them through life. Babies are fragile and need protection, although paradoxically in black magic myths, baby dolls provide protection for their owners.'

Nicha Lapevisuthisaroj

'I wanted to express how the spiral within nature's design can be adapted and manipulated into a manmade structure in a brutalist style. I have explored the purpose and strength of repeated patterns in nature and how these natural patterns have influenced and transformed manmade design.'

Nicholas Willis

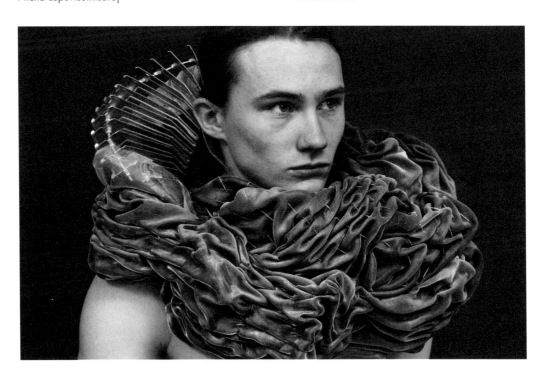

Helena Yi

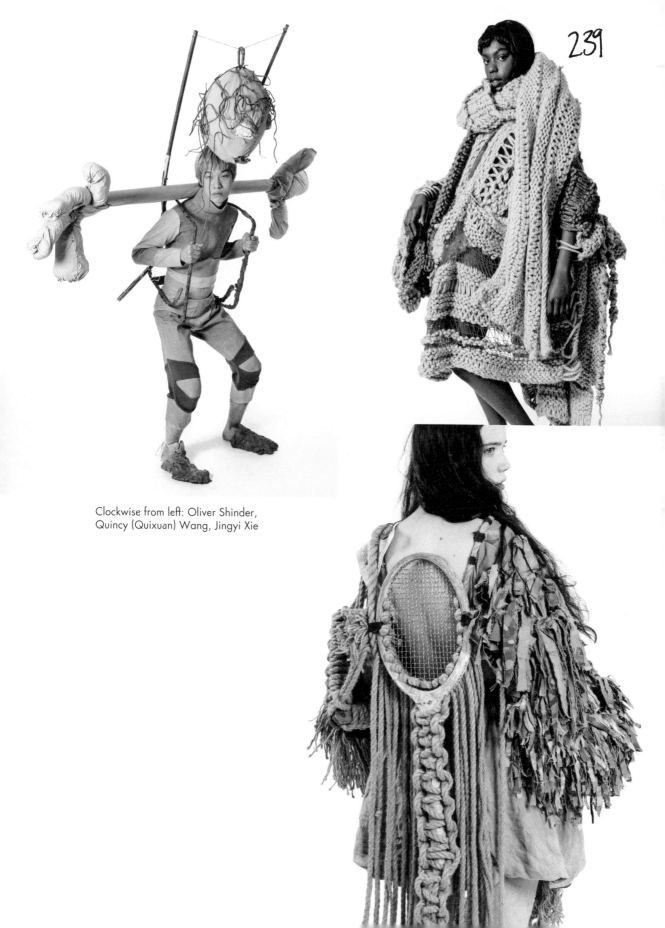

Clockwise from left: Oliver Shinder,
Quincy (Quixuan) Wang, Jingyi Xie

Fine Art

'I am interested in exploring the relationship between temporality, balance and fragility with reference to contrasting materials. In this piece, I am concerned with creating anticipation and an illusion of the subversion of a material's preconceived strength or purpose.'

Hannah Billett

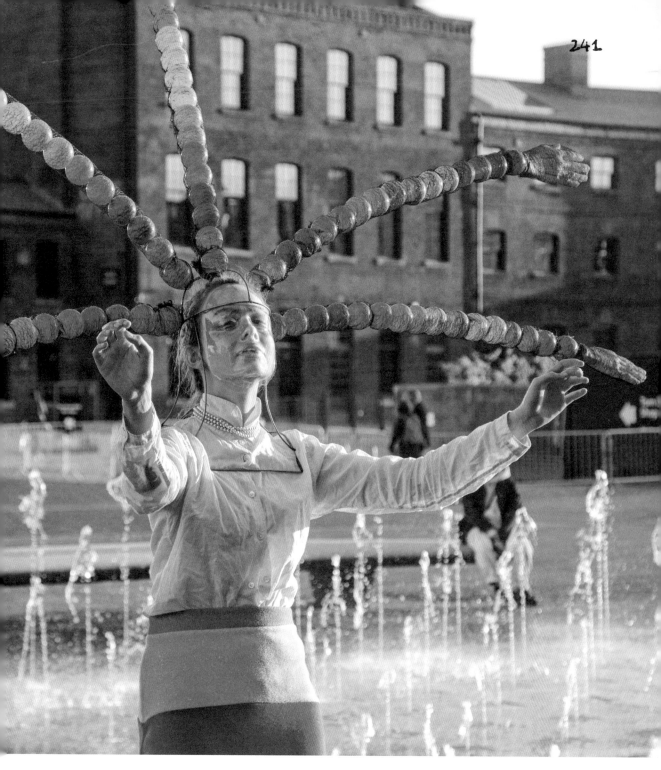

'This work is about the creation of a new religion.
I am the god of my own religion. My followers are
wearing a reproduction of my face and this is
integral to the terms and conditions of the religion.
I share my body parts with my followers and that is
what unites us.'

Ika Schwander

Communication Design

'This spade is the sole object you will need to survive
in a post-Brexit world. There is no task too big or
too small for this trusty tool. Go forth with your
spade, knowing you will survive the aftermath
of Brexit.'

Poppy Gurney

Defence 32

How to build a wall

Walls provide us with shelter and security from the elements.
They keep wind, rain, snow and other undesirables out.
Here is a way to construct a wall that does not cost the earth.

1. Mark out a long rectangle with markers – even twigs poked into the earth will do for the border of the wall.

2. Dig in between your markers, using the spade, until you reach shoulder height (you need to be able to climb out).

3. Once you have reached shoulder height continue to dig but dig lengthways instead.

'I created my own cult, "The Church of the Omnipresent Success Energy", a New-Age religion that asserts that our potential for success is controlled by trans-dimensional energy particles that surround us at all times.'

Joseph Learmonth

Chapter 12

Audience

The Portfolio

The university application process for art and design conjures up an image of the prospective student bringing their life's work to present at an interview. Yet increasingly, applications for university courses and jobs now involve creating digital and online portfolios in order to demonstrate the potential of your work and ideas. In fact, across the creative industries, the whole notion of a portfolio has significantly changed as artists and designers engage with audiences and showcase their work and interests across a range of digital platforms.

A prospective course, client or employer may be just as interested in your Twitter or Instagram feed as your edited portfolio of work. Developing a strategy for editing, sharing and constructing a narrative around your practice across a range of platforms and formats is therefore an essential and empowering aspect of presenting and promoting both yourself and your work.

Think about your portfolio as a tool for showcasing your critical voice, viewpoint and ongoing experimentation alongside using it to present finished projects. This turns the whole idea of a portfolio into a more complete window into your creative practice and allows you to demonstrate your engagement with your chosen field. It not only gives you the opportunity to explain your knowledge of the industry and its innovations, but also to participate in and influence the activity and debate around what you do. Your ability to communicate, your attitude and your personality are given equal weight in your edited output.

By showing confidence in your ideas and critical voice, you will quickly find that people are more inclined to want to collaborate with you and recommend you to others. Everyone has to find an approach that they are comfortable with, but it is important not to be put off by the concept of self-promotion; you can be confident and enthusiastic about your work without being egotistical. In asserting your presence across multiple platforms, you are much more likely to make the connections that will contribute to establishing a successful and sustainable practice.

Having completed a selection of the projects included in this book, you are now in a position to assemble a portfolio that demonstrates your ability to explore creative possibilities, solve problems and successfully manipulate a range of materials and processes. You will also be able to show your capacity to work independently as well as collaboratively, and to situate your work in the world with a view to maximising its impact. Your sketchbooks will reveal your commitment to an in-depth investigation of your subject, your approach to research, your ability to think through drawing and making and the originality of your visual language. These are the aspects of your creative practice that will allow you to progress on to a specialist degree course and ultimately achieve success within your chosen field.

Portfolio tips

- Creating a portfolio in any format should be a process of storytelling. It is therefore important to establish the context of your work and to demonstrate where the work is sited, how it is engaged with by its audience and your ambition for its impact. This approach highlights the potential of your ideas rather than simply showcasing your technical skills.

- A portfolio is your chance to show the range of your creative practice. You will need to be motivated to self-initiate projects and showcase speculative works that highlight personal themes and interests alongside school projects or commercial briefs.

- Attention to detail in terms of presentation and organisation shows you value your work and will directly impact how much time your audience spends looking at your portfolio.

- Your portfolio should not be a complete archive of your work to date. It is important to select only the examples that are most relevant to your current interests and concerns.

- For each course or job that you apply for, you should edit your portfolio to suit the context in which it will be viewed. Make a careful study of the organisation you are pitching to and put together a focused version of your portfolio. Think about which projects, skills and approaches you would like to foreground.

- We would advise that at least one third of your portfolio relates to your research and development process.

Knowledge exchange

A collaborative, creative endeavour that translates knowledge and research into impact in society and the economy.

Knowledge Exchange Concordat, 2020

Artists and designers are innovators who often see and imagine the world differently, and they can use this unique perspective to innovate and imagine new possibilities which can have impact in a wide range of contexts. Creative collaboration underpins everything that we teach in art school, and it also has huge value both commercially and societally. Knowledge Exchange is a process of connecting these creative and collaborative skills with a partner, business or institution outside the university with the aim of bringing about creative innovation, entrepreneurship and societal change.

'Knowledge exchange demonstrates the power of a creative education by empowering students to have confidence to challenge and redraw the boundaries of their disciplines and apply creative thinking in new and unexpected ways to drive positive change.'

Darla-Jane Gilroy, Associate Dean of Knowledge Exchange, Central Saint Martins

CSM Loves NHS
Co-authors: Oonagh
O'Hagan & Jo Simpson

During the COVID-19 lockdown crisis when there was a major shortage of hospital scrubs within the NHS, CSM Foundation developed a project called CSM loves NHS. We designed a downloadable pattern with the aim that our students, no matter where they were in the world, could use the pattern and make scrubs for distribution within the NHS.

Following on from this, we were approached by the world-renowned Great Ormond Street Children's hospital. They came to us with an interesting idea about making bespoke gowns for their long-term patients. The hospital noticed that over time these patients began to lose their sense of identity and they saw this collaboration as an opportunity for long-term patients to reconnect with a sense of identity and self.

Working from an anonymous patient profile of an eight year-old who had already been in the hospital for three years, the students were challenged to consider how colour, pattern and texture could affect the well-being or even the recovery of a patient.

The final garment evolved through workshops in the college, two-way communications, feedback and a critique by the patient. All students learnt how to pattern cut, create original repeat pattern print designs through making scrubs for the NHS and understood the impact they could make in the future as designers through the introduction to themes and theories such as sustainability and social design.

'This project introduced me to the world of social design and that is something I have taken into my own practice, looking at how I can make a positive change within fashion design.'

Ben Wigmore, CSM Foundation student

Above left: Chris Kelly
Above right: Johnny McLean
Below: Yuura Asano

Afterword

Professor Jeremy Till,
Central Saint Martins

I have always thought of the year in Foundation as one of the most generous offerings in the education landscape. It provides an open space to test and find oneself, allowing for failure as a means to discover success. In the current UK context of both school and university education, such generosity is much needed. In schools we are witnessing what feels like an assault on creative arts education, as metrics and conservative values squeeze out what is considered non-essential. In the university sector, the creative arts are exposed to systems and measures that are sometimes incompatible with our core values and processes. And at a global level, the toxic forces initiated by Trump and Brexit are, in their erection of various forms of boundaries, antithetical to the creative urge, which necessarily operates across borders. Finally, as we face climate breakdown, we urgently need the imagination of the next generation to enable us to envisage new futures. In this light the Foundation year is an incredibly important moment to refuel creativity, both individually and collectively.

As this book makes clear, there are no hard and fast rules to follow; it is a question of attitude that makes successful and happy Foundation students what they are – a spirit of openness and curiosity combined with the qualities of application and precision. At Central Saint Martins and the University of the Arts London, we move away from the rule book and replace it with a support platform on which each student is empowered to be themselves. This book is one such platform, a presentation of multiple identities.

I remain resolute in my belief in the creative arts as a cultural bedrock for society, and also as a driver for societal change. I see such optimism so clearly expressed in the work of Foundation students, who are often channelling their emerging concerns and identities through their work, stating clearly and loudly, 'We are here, take heed,' and so collectively reflecting the obsessions and directions of Central Saint Martins and UAL at large. This book captures this spirit perfectly. It is not a set of prescriptions but a snapshot of opportunities that our students and future students might take in shaping the world.

Acknowledgements
Lucy Alexander
and Timothy Meara

This book is the culmination of over 15 years of shared experience teaching on the Foundation course at Central Saint Martins. Since meeting as students at the Royal College of Art, we have maintained a continuous dialogue with one another about art, design and education. More recently, we have taken our shared ideas and commitment to progressive pedagogies into a research practice where we investigate the power and potential of exploring collective work. A lot of this book has arisen from this process of working together and thinking alongside one another.

First and foremost, we would like to thank the Foundation students whose work populates the pages of this book. As well as all the other students we have taught and who have informed and inspired us with their energy, their enthusiasm and their willingness to submit themselves to the intense and demanding experiences of the Foundation course at Central Saint Martins.

This book would not have been possible without the contribution and input of our colleagues and co-authors. Their specialist knowledge and experience has allowed us to cover a much wider range of disciplines and activities, making this book as reflective as possible of the current Central Saint Martins Foundation course.

We would like to give special thanks to our Programme Director, Christopher Roberts, who has supported this project from the beginning and who encourages us and gives us the space to constantly evolve and innovate in our delivery of the Foundation course.

Thank you to Ignacia Ruiz, our very talented illustrator, colleague and friend, whose drawings bring the book to life and perfectly characterise our words. And to Martin Slivka who has photographed most of the work in these pages, from sketchbooks and studio spaces to students scaling chairs, with patience and care.

To Fraser Muggeridge and his studio for designing a beautiful book which makes sense of the course. Particularly to Jules Estèves, for his incredible commitment to the project and for his collaborative spirit. And Michela Zoppi too for getting things to the finish line at the end of the design process.

We would also like to thank Francesca Leung who proposed us for this project and Zara Anvari who initiated and commissioned this book. Thanks also to our editor Jenny Dye for her insightful correction and to our art director Ben Gardiner for allowing us such involvement in the design process.

Thank you to Grayson Perry for his foreword and for the inspiration he provides students and staff as Chancellor of the University of the Arts.

At Central Saint Martins, Jeremy Till, Head of College, for his written contribution, Monica Hundal and Hannah Sim from the Innovation and Business team and Stephen Beddoe, Director of External Relations. Also to the College's Refresh Fund which kindly supported part of the development of this book.

On a personal note, we would like to thank our partners Martin Slivka and Isabelle De Cat and our parents for their valuable input with shaping our words and for their endless support and encouragement.

Image Credits

Illustration

All the Illustrations in this book are by Ignacia Ruiz.

With the exception of:

William Davey, Course Diagram, p. 2

Photography

All photography is by Martin Slivka.

With the exception of:

Kevin Carver, Foundation studio, Central School of Art and Design, 1985, p. 10
Kevin Carver, Foundation studio, Central School of Art and Design, 1983, p. 11
Josh Shinner, AW11 *Jumping Girl*, p. 50
Ben Westoby, *Orlando*, 2014, courtesy of the artist and Roman Road, p. 51
Lucy Alexander, Body and Form student work, p. 99
Tim Meara, Build It workshop, p. 120–5
Diandra Elmira, p. 126–7
Theresa Marx, Birgit Toke Tauke Frietman 2015, p. 145
Mark Laban, Rustic Stools, 2017, p. 146–7
Chris Beldain, Rahmeur Rhaman AW19, p. 148
Tim Meara, Chris Kelly Draping workshop, p. 173–5
Tim Meara, Fashion & Textiles garments, p. 182–7
Adrian Scrivener, site visit, p. 196
Lucy Alexander & Tim Meara, Park, 2018, p. 198–201
Lauren Best, *Forest Survival Kit*, p. 210–11
Richard Nicholson, Carina Eke footwear, p. 212
Max Barnett, Imogen Colla neck piece, p. 213
Lucy Alexander, Commune in the Future House, p. 223
Scene Peng, Commune in the Futuro House, p. 224–7
Lucy Alexander, Paolina, 1m², p. 234
Max Barnett, Holly Beighton headpieces, p. 236
Max Barnett, Nicholas Willis neck piece, p. 237
Tim Meara and Jo Simpson, p. 238–9
David Poultney, Ika Schwander performance, p. 241
The workshop pictured on p. 120–5 was run by Alaistair Steele and Helmert Robbertsen with the participation of 3DDA Foundation students.

Page numbers

All the page numbers in this book were individually written by the staff and students on the Foundation course in 2018/19.

Cover image

Wall Mounted Chairs, a sculptural performance by Sabina Giorgi.

Instagram

@csm_foundation
@fashion_textiles_csm
@fine_art_csm_foundation
@gcd_csm_foundation
@3ddafoundation

An Hachette UK Company
www.hachette.co.uk

First published in the United Kingdom in 2023
by Ilex, an imprint of
Octopus Publishing Group Ltd
Carmelite House
50 Victoria Embankment
London EC4Y 0DZ
www.octopusbooks.co.uk
www.octopusbooksusa.com

Material in this edition was previously
published as *Central Saint Martin's Foundation:
Key Lessons in Art and Design*

Distributed in the US by
Hachette Book Group
1290 Avenue of the Americas
4th and 5th Floors
New York, NY 10104

Distributed in Canada by
Canadian Manda Group
664 Annette St.
Toronto, Ontario, Canada M6S 2C8

Publisher: Alison Starling
Editorial Director: Zena Alkayat
Commissioning Editor: Zara Anvari
Managing Editor: Rachel Silverlight
Editor: Jenny Dye
Art Director: Ben Gardiner
Designers: Fraser Muggeridge studio
Production Manager: Lisa Pinnell

ISBN 978-1-78157-934-3

A CIP catalogue record for this book is available
from the British Library.

Printed and bound in China

10 9 8 7 6 5 4 3 2 1

MIX
Paper | Supporting
responsible forestry
FSC® C008047